Introduction to
Drawing the Human Body

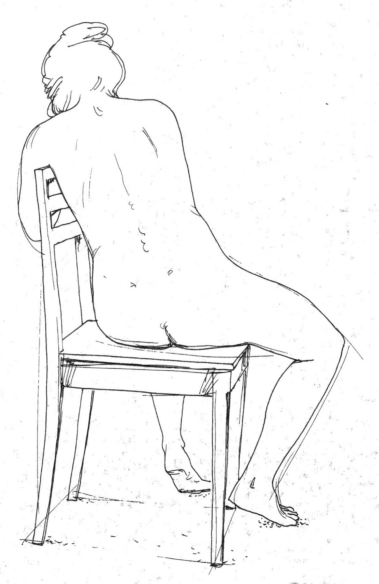

GIOVANNI CIVARDI

SEARCH PRESS

First published in Great Britain 2014 by Search Press Limited, Wellwood, North Farm Road, Tunbridge Wells, Kent, TN2 3DR

Originally published in 2001 as *Forma e Figura: Introduzione al Disegno del Corpo Umano* by Il Castello S.r.l., via Milano 73/75 - 20010 Cornaredo (Milano), Italy.

Copyright © Il Castello S.r.l., via Milano 73/75 - 20010 Cornaredo (Milano), Italy.

English translation by Sonia Atkinson for Cicero Translations.

ISBN: 978-1-84448-609-0

The drawings reproduced in this book were created by working with professional models and consenting adults. Any resemblance to other persons is purely coincidental.

Printed in China

'Incitement to humility: whatever you do, there will always be someone who does it better than you...'
Giovanni Civardi

'Simplex sigillum veri (simplicity is the seal of truth)'
H. Boerhaave

'Ours is a sad age, in which nothing seems to be of any value and everything seems to have a price, everything seems to be focused only on the present, with no nostalgia for the past and no hope for the future.'
Giovanni Civardi

CONTENTS

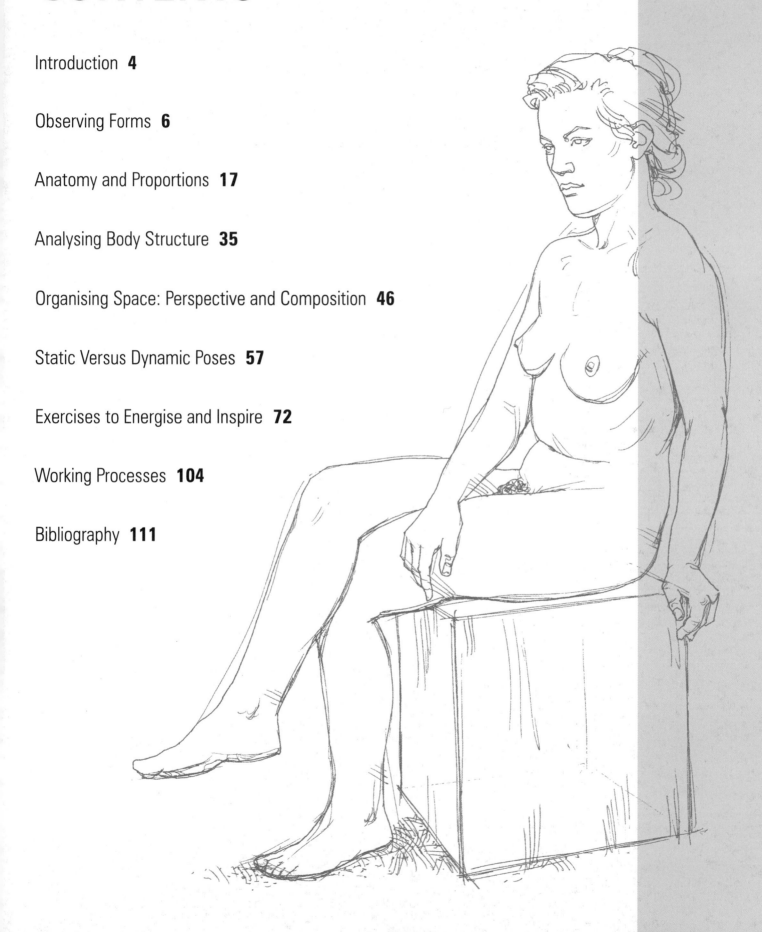

INTRODUCTION

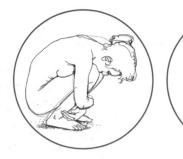
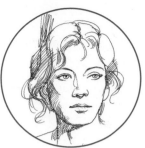

'Il y a toujours quelque chose d'absent qui me tormente.'
[There is always something missing that torments me]
Camille Claudel

'...il faut trouver le secret du beau par le vrai...'
[…you must find the secret of beauty in reality…]
J.A.D. Ingres

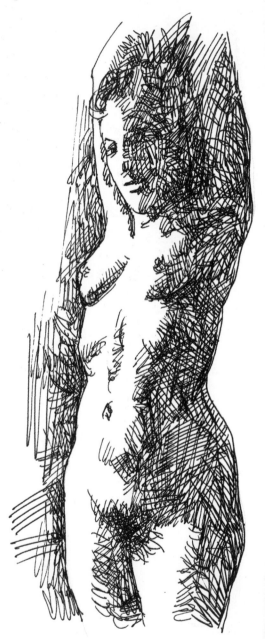

The sketches in this book were made during life-drawing classes to provide students with clear graphic illustrations of certain key issues in the depiction of the human body. While the principles of life drawing and observation can apply to any subject, the human figure is certainly the most demanding and complex (as well as the most fascinating) subject to tackle, and therefore it requires particularly close attention.

When instructing my own students, I think it highly important to emphasise that there are many different ways and methods of achieving a thorough and intelligent understanding of the human body. These methods may sometimes be contradictory, sometimes synergistic and sometimes complementary and, although all this may be confusing and a little discouraging, we should remember that real artistic development is a constantly evolving process, and this is what the life drawing process should be about. Careful observation and skillful expression of the human form benefit from ongoing mental, perceptive, emotional and hands-on training, which also stimulates the mind, increases awareness and makes each stroke of the pencil or brush more precise and meaningful. If you settle for routine outcomes and avoid tackling new or unusual drawing tasks the risk is that the skills you have acquired will stagnate, causing you to produce mundane results rather than art.

This book is structured in the same way as one of my earlier works *Sketching People: Faces and Figures*, however, rather than focusing on the anatomical perspective as *Sketching People* does, this book focuses more on depicting the external forms of the figure from a purely visual perspective. Each set of illustrations is accompanied by a very brief explanatory text, which I hope will be sufficient to outline the fundamental guidelines for each exercise.

The drawings (which are very simple, in keeping with their intended use as teaching aids) were all made in pen and black Indian ink or fine felt-tip pen on smooth Fabriano paper measuring 33 x 48cm (13 x 19in). They were almost all drawn from life, in the 'nude' classroom. Some of the poses required by the male and female models were very uncomfortable and unusual, and I would like to take this opportunity to thank them for this.

Giovanni Civardi
Milan, March 2001

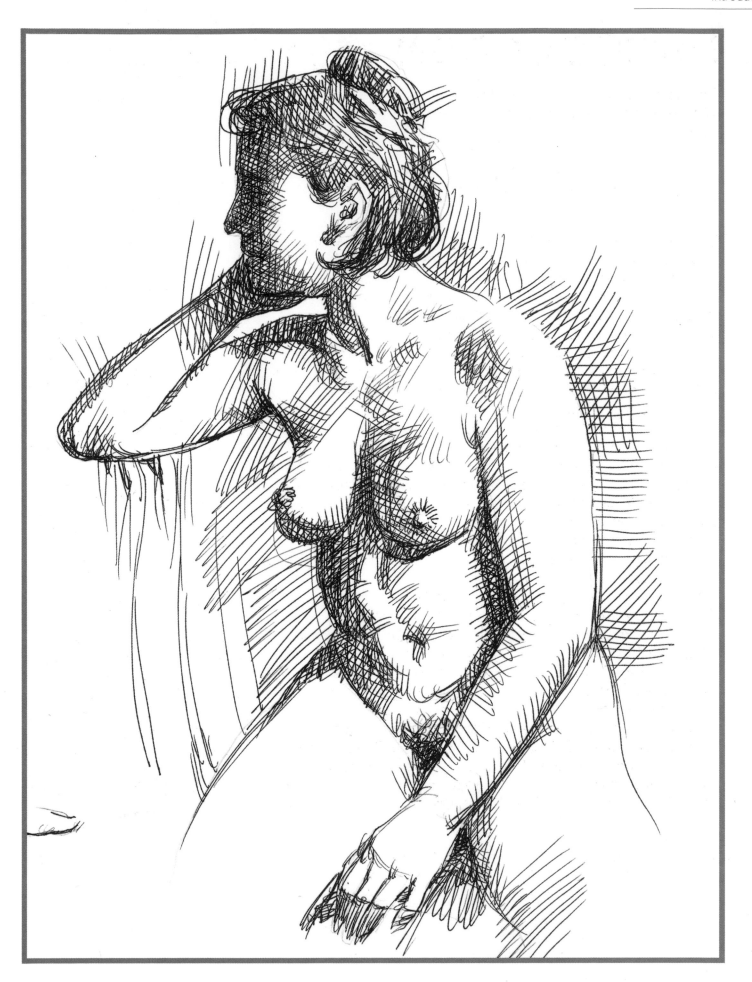

OBSERVING FORMS

'Apprendre à voir est le plus long apprentissage de tous les arts.'
[Learning to see is the longest training of all the arts.]
Edmond de Goncourt

PLATE 1 (OPPOSITE):
ASSESSING DIMENSIONS AND PROPORTIONS

When drawing a model from life, you need to train your eye to assess the proportions of the body parts you are observing with accuracy. You need to make comparisons between the dimensions of the different individual parts and between the dimensions of the individual parts and the body as a whole. This illustration shows some important measurements needed to acquire good observation skills:

1. Select and define the height of the figure in the drawing, marking the upper limit (A) and the lower limit (A1) on the paper.

2. Assess, by comparison, the maximum width (B–B1) and the maximum height (A–A1), which can be identified by observing the model's body; it is sometimes also useful to measure intermediate widths in important areas of the body (such as the shoulders, B2–B3).

3. Find the halfway point in the height of the figure and then use this to identify the central point of the composition by crossing this point with the mid-width.

4. Use vertical and horizontal alignments (a plumb line can be used for the vertical observations) to measure certain key points on the model and see how they correspond to each another, observing their relative positions and using the same procedure to transfer them to the drawing. During this phase, it is also useful to check the diagonal lines and the size of the angles created between individual body parts.

5. Compare the relative dimensions by assessing the width and length of the various body parts, the adjacent negative spaces and the distances in the drawing between the body profiles and the edges of the paper. Alternatively, if the model is in a complex pose, choose the dimensions of a body part (the height of the head, the length of the forearm, the width of the knee, etc.) and compare this to those of other parts in order to achieve the correct proportions.

 The measurements proposed in the steps above should not be treated as a geometric or mechanical examination of the human body, but instead as training for the eye, helping it to find useful reference points on the model and to assess whether they have been accurately interpreted in the drawing.

Plate 1: Assessing Dimensions and Proportions

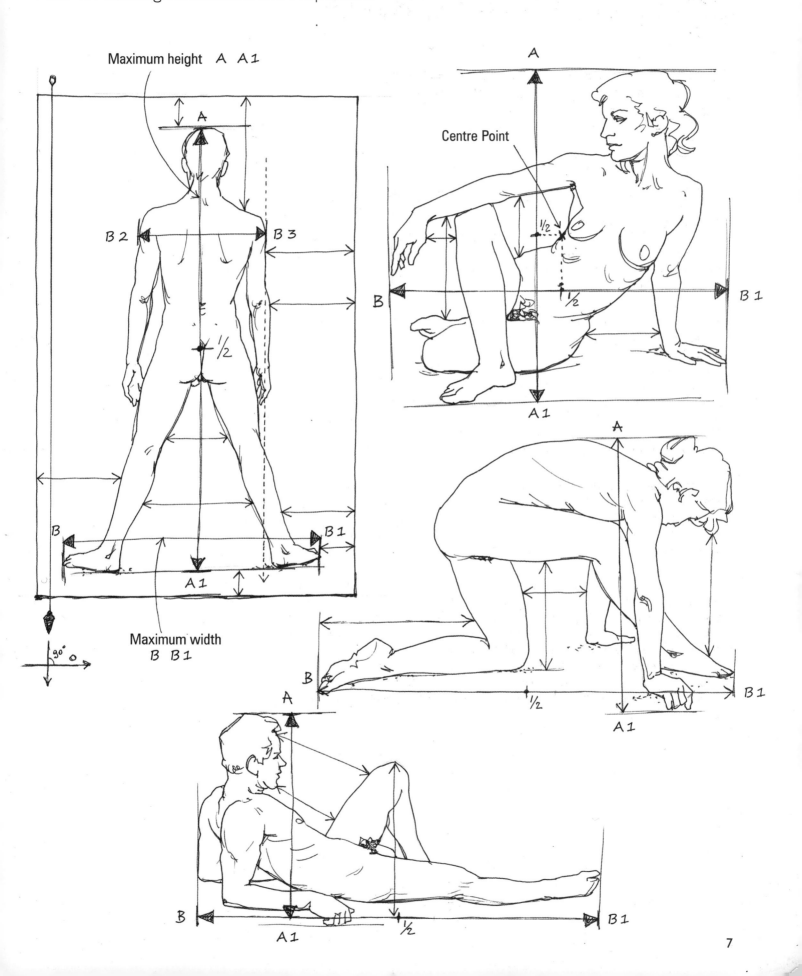

Maximum height A A1

Centre Point

B 2

B 3

½

Maximum width
B B1

90° 0

½

½

½

PLATE 2 (OPPOSITE): DRAWING NEGATIVE SPACES

While the object you are depicting – the figure – occupies a physical space and is called the 'positive' form, the spaces around it and between its parts, such as between the arm and the torso, are called the 'negative' spaces. These shapes make forms (negative forms) which need to be observed and considered alongside the positive forms of the subject because they are an integral part of the composition and are needed to create a complete image. The shapes of these negative forms can usually be compared to flat geometric forms (triangles, circles, polygons, etc.) and it is therefore easy to assess their proportions and use them to check that the drawing of the figure is correct.

PLATE 3 (PAGE 10):
ASSESSING THE OVERALL GEOMETRICAL SHAPE

Figure drawing begins by looking for the simplest overall basic shape suggested by the model's pose. We need to apply the principle of geometry, using abstraction to simplify the human form into linear or solid geometric configurations (squares or cubes, circles or spheres, triangles or cones, etc.). All natural forms can be traced back to elementary geometrical shapes – obviously in a very schematic fashion – giving us a better understanding of their volume, their occupation of space and their perspective. Recognising the fundamental geometrical shape does not just serve a practical purpose in terms of choosing the most suitable format for the drawing (that is to say the length and width of the support to be used, and the relationship between the measurements), and for setting out the image upon it, but it also helps with the expressive characterisation of the figure.

In terms of visual perception, the square is created by the intersection of vertical and horizontal lines. The forms deriving from it (rectangle, cube, etc.) are very stable and therefore suggest static and stable poses of the model. The triangle (such as the cone, pyramid, etc.) is created by the meeting of oblique lines, and so the resulting composition has a greater sense of movement because the balance of the form is only maintained by the equal pressure of the angled lines. The circle (such as the ellipse, the sphere, etc.) represents never-ending continuity and is not clearly defined in any direction, lacking reference points such as a start and a finish.

Plate 2: Drawing Negative Spaces

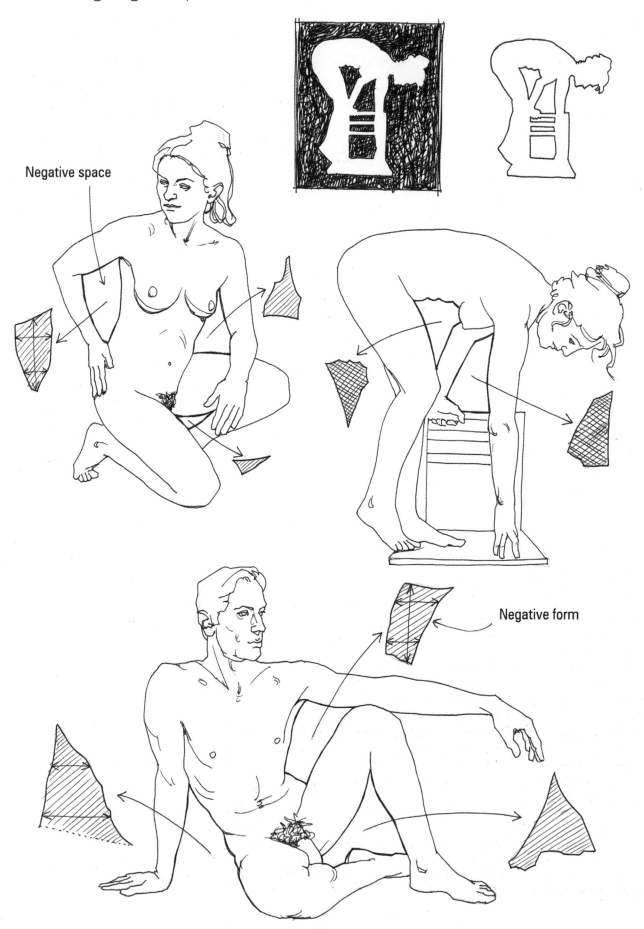

Negative space

Negative form

Plate 3: Assessing the Overall Geometrical Shape

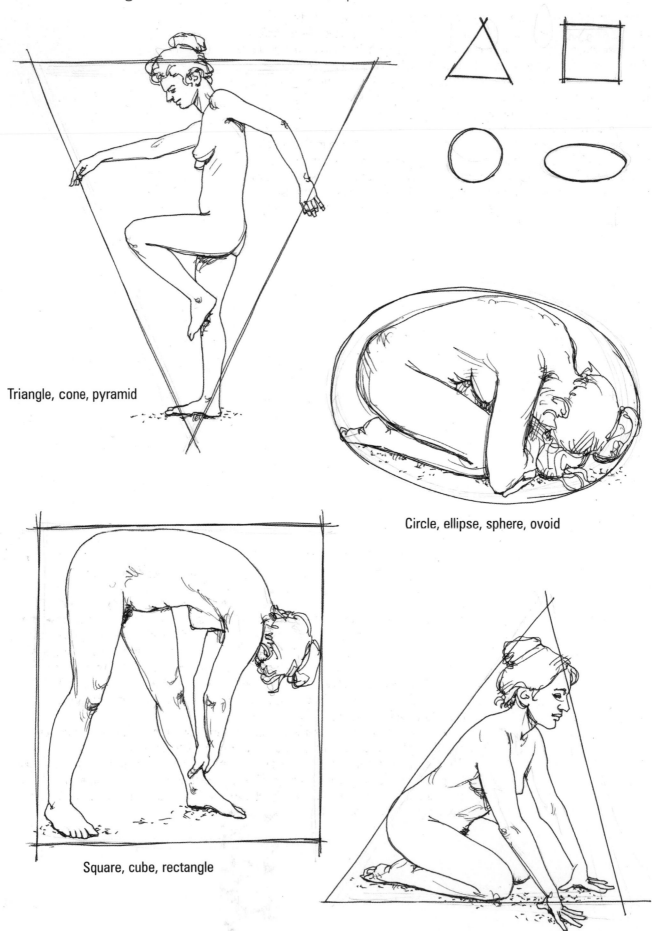

Triangle, cone, pyramid

Circle, ellipse, sphere, ovoid

Square, cube, rectangle

PLATE 4 (PAGE 12): OPEN VERSUS CLOSED FORMS

In artistic terms, form is the relationship between volumes, colours and lines, providing the foundations for the expressive qualities of the elements that describe the subject as a whole. Looking at it in these terms, a 'closed' form can be recognised when it is clearly circumscribed by the drawing, almost engraved into the space like an abstract linear vision, in which colour is subordinate to drawing. An 'open' form, on the other hand, tends to fuse into the atmospheric space by means of tonal gradations of chiaroscuro, suggesting a pictorial vision that implies the use of natural expressive means, such as light and shade.

In our case, we need to focus our attention on the character of the form, which is an expressive quality suggested by the model's pose. In this sense, the closed form can indicate concentrated energy, an implosion, static closure or turning in on oneself, and concentrated centripetal forces, while the open form can inspire a sensation of dynamic expansion, explosion and centrifugal irradiation. Similar tensions can be observed in the various facial expressions: 'closed' expressions such as negative and sad or 'open' expressions such as positive and joyful.

PLATE 5 (PAGE 13):
ASSESSING THE CHARACTER OF THE POSE

Drawing the human figure and grasping its character means understanding the essential elements and main characteristics of the model, not just in terms of form, but also pose (the physical and mental attitude assumed by the model), and the model's ability to get into and maintain that pose. The physical form of an object is determined by its contours and spatial configuration, with clearly defined directions and dimensions. Meanwhile, the perception of 'character' is based on the essential configuration (rotund, triangular, vertical, etc.) and structural conformation (direction of the main axes, contrasts and analogies in spatial orientation, surfaces, volumes, etc.).

When looking at a form, we see its individual parts as well as the whole, but the artist should start by assessing it in entirety by identifying the simplest overall law of construction ('Gestalt', or the essence of the complete form). Observing the model, it is useful to recognise the fundamental or prevalent tendency of his or her physical pose (vertical, angled, curled up in a rounded form, horizontal, etc.) and to perceive the emotions evoked by that pose (calm, tense, precarious, uncomfortable, serene, strained, etc.).

Plate 4: Open Versus Closed Forms

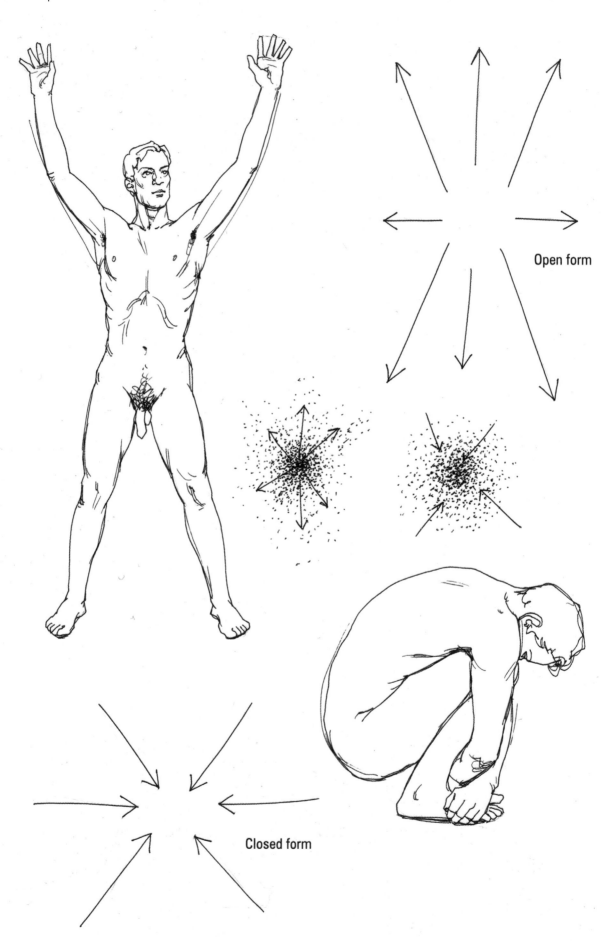

Open form

Closed form

Plate 5: Assessing the Character of the Pose

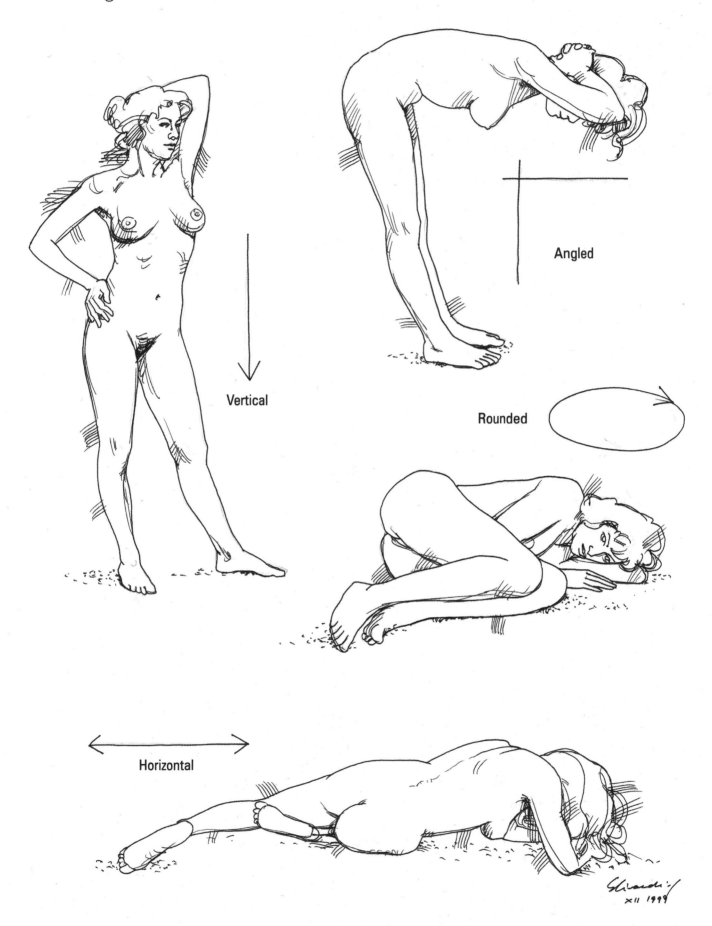

Vertical

Angled

Rounded

Horizontal

PLATE 6 (OPPOSITE): EXPRESSION

Expression is the act of showing, indicating or representing an emotion, a concept or a sentiment. In art, expression takes place through different means of communication (gestures, words, sounds, etc.) responding to the fundamental principle of the convention. We can express ourselves in figurative art thanks to the fact that gestures, either through convention or resemblance, are attributed with meanings.

When drawing the human figure, expression can be identified in the gesture, the action suggested by a physical movement, the unstable pose, and the dynamic tensions between different parts of the body. In all these situations, only a limited amount of expression is provided by the illustrative meaning of the pose, with most of it being conveyed by the structural contrast between the individual body parts as they are oriented in space or intertwined, communicating a sensation of incipient movement or, in any case, of muscular or intentional tension to the viewer.

PLATE 7 (PAGE 16): ALTERING WHAT YOU SEE

In literal terms, to deform means to alter a form and always suggests a relationship between what is there and what ought to be there. The deformed or altered object is seen as a deviation from that which is normally held to correspond to a known, recognisable and truthful form. More generally, by using 'deformation' we digress from regular geometric harmony or show indifference to the proportions of the natural world. All artistic creations involve changing or deforming objective reality in certain ways, especially when it comes to the human body. In fact, the way the artist sees reality is conditioned by his or her own feelings, style and interpretation. However, some absurd alterations are unpleasant or unacceptable, while other changes may be more intense but are still in keeping with an aesthetic ideal, making them better received. Rather than 'degrees' of deformation, there is 'quality' of deformation: this is all about the level of perfection achieved by the artist and its formal expressive justification.

One useful exercise is to draw progressive alterations of the human nude, starting with careful observation of the model from life, then going on to accentuate certain bodily characteristics or, even more effectively, emphasising the structural tensions induced in the body by the pose.

Another interesting exercise is to give your drawn figure a different body type to that of your model. For example, in the frequent event of a balanced and average body, it could be drawn as if it were a short and stumpy body (accentuating it horizontally, with short limbs and a broad trunk) or as if it were a tall and lanky body (mainly developed in height, with long limbs, and an elongated and thin trunk), attributing each figure drawing with physical and character traits typical of the body type in question, in addition to making alterations in size.

Plate 6: Expression

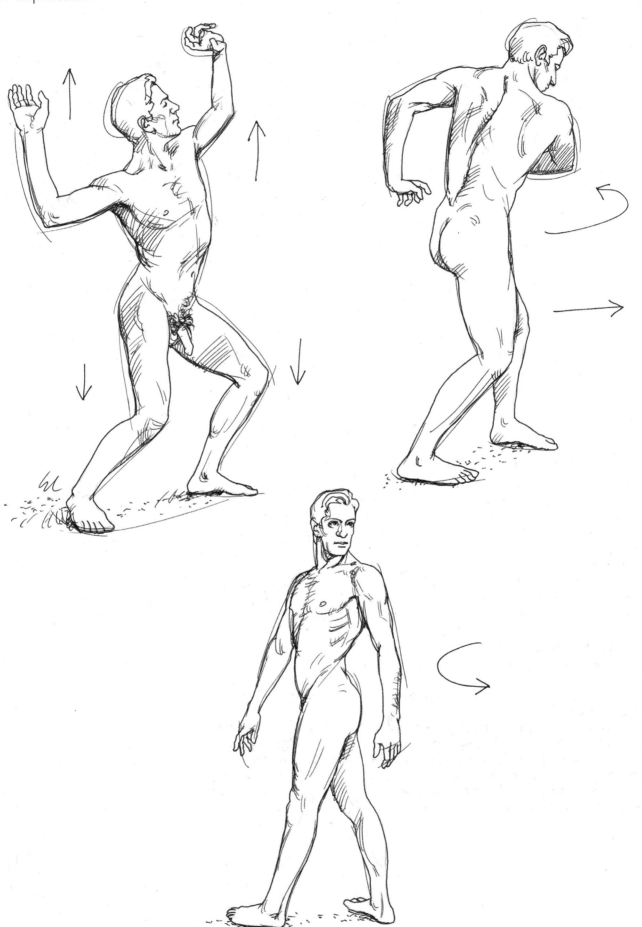

Plate 7: Altering What You See

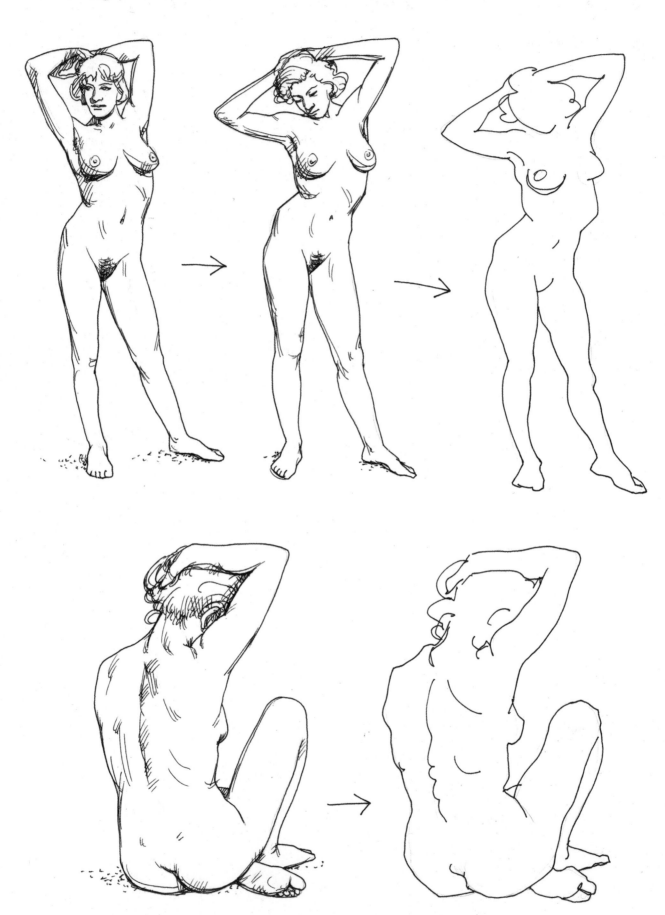

ANATOMY AND PROPORTIONS

'There are no transgressions if there are no limits.'

PLATES 8–10 (PAGES 18–20): THE SKELETON

Studying human anatomy is indispensable for the artist, whatever style he or she intends to work in. A thorough knowledge of anatomy enables the artist to depict the nude or clothed body correctly and, above all, effectively and in keeping with his or her intentions. Anatomical study is useful for gaining knowledge about the working form of the body, the proportional relationship between body parts, and the dynamic behaviour of the body. It can also be used to help learn about the most complex biological structure in nature and to investigate it in the most extensive and thorough way possible, supplemented by considerations on the increasingly close and associated connection between the human body and its historic, social, cultural and artistic environment.

In order to grasp a full understanding of these aspects of the human figure, it is preferable to begin with careful observation of the human body from life, evaluating it in visual terms (profiles, volumes, dimensions, character, etc.). Only then, after having practised observing the external forms and having grasped the perceptive aspects, can it become useful to carry out further research into strictly anatomical subjects, such as osteology (the study of bones), arthrology (the study of joints), myology (the study of the muscular system), morphology (the study of the structure of outward forms), etc.

As a group, the bones form the main weight-bearing structure of the human body, providing it with internal support. It is therefore of great importance to the artist – perhaps even more so than the muscular system – because it is the reason for the body's overall structure and the proportional relationships between the individual parts, both in static poses and during movement. The axial skeleton forms the central vertical axis of the body and essentially includes the skull, the spine and the rib cage. The appendicular skeleton comprises the appendages – it includes the bones of the limbs as well as the collarbone and pelvic girdle. The distinction is significant for artists because the axial skeleton plus the pelvis is the portion that must be intuitively understood straight away and considered very carefully when looking at a figure, given that it defines almost the entire pose of the body and its overall character. With the exception of the pelvis, the appendicular portion can take on an almost secondary meaning, which is not essential, partly modifiable and easier to interpret.

As well as providing the body's support structure, bones also determine its external forms to a large extent because, in some regions at least, they are positioned just beneath the skin and can be made out through a thin adipose (fatty) or muscular layer, for example, in the face, on the back of the hands and feet, on the knees, etc.

The cranium consists of two portions: the braincase (frontal, parietal, temporal, occipital, etc.), which is ovoid in form with the smaller pole towards the front, and the facial bones (zygomatic, nasal, maxilla, mandible, etc.), of a roughly pyramidal form with the apex towards the chin.

The skeleton of the trunk is formed by the rib cage – twelve pairs of ribs jointed to the spine and connected to the sternum at the front with the exception of the last two pairs. The rib cage is ovoid in form, flattened slightly at the front and back and broader at the bottom. The spine is a series of 32/33 vertebrae arranged one on top of the other to provide fundamental flexible support to the body. It is conical and very elongated in form, arranged in broad concave and convex curves that correspond to the cervical spine, the thoracic spine and the lumbar spine when the body is in an erect position.

The bones of the upper limbs comprise the humerus, the ulna and radius, plus the bones of the hand (carpus, metacarpus, phalanges) and are connected to the rib cage by the shoulder girdle (clavicle and scapula). The bones of the lower limbs comprise the femur, the tibia and fibula, the patella (knee) and the foot bones (tarsus, metatarsus, phalanges) and are connected to the spine (sacrum) by the pelvis (ilium, ischium, pubis).

The individual bones are joined by special anatomical structures, joints, which hold them together while also permitting reciprocal movements within defined mechanical limits thanks to the effect of muscle action. The diarthrosis joints (also known as synovial joints) permit the most extensive movements. There are various types of diarthrosis joints, found primarily in the limbs (for example, the elbow, the knee, the shoulder, the hip, etc.). The synarthrosis joints, on the other hand, are practically immobile and stable (found between many cranial bones, in the pelvis, etc.).

You can currently obtain artificial skeletons made from plastic casts of an authentic skeleton and jointed to re-create the relationships between the bone and the natural structure of the skeleton with a good degree of realism. These skeletons can be found in many art schools and artists can use them to study body parts and the body as a whole, working from different viewpoints and arranging the body (as far as possible and always making sure that the joint movements look natural) so as to simulate simple body poses.

Plate 8: The Skeleton

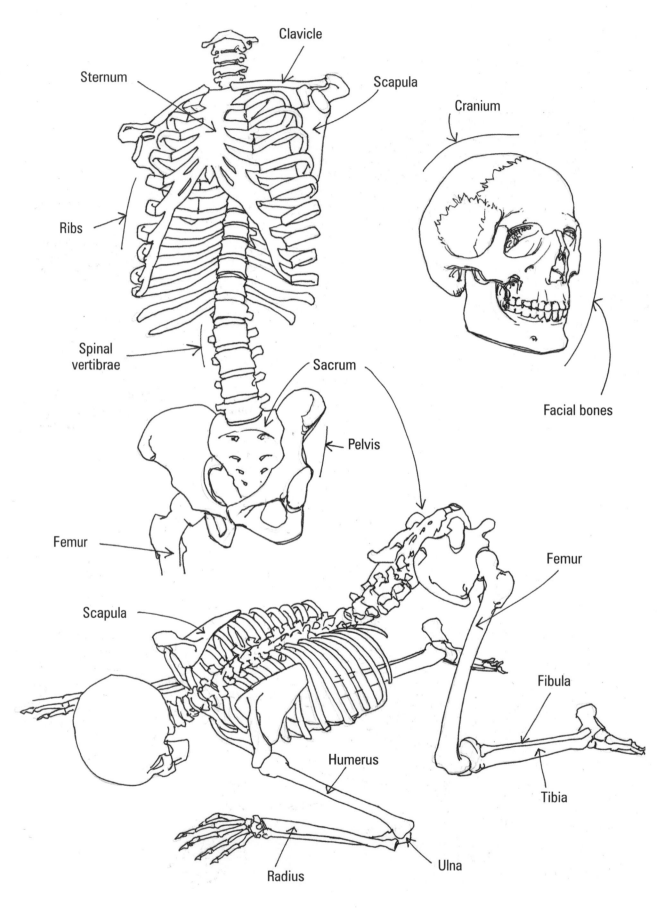

Clavicle

Sternum

Scapula

Cranium

Ribs

Spinal
vertibrae

Sacrum

Facial bones

Pelvis

Femur

Femur

Scapula

Fibula

Humerus

Tibia

Radius

Ulna

Plate 9: The Skeleton

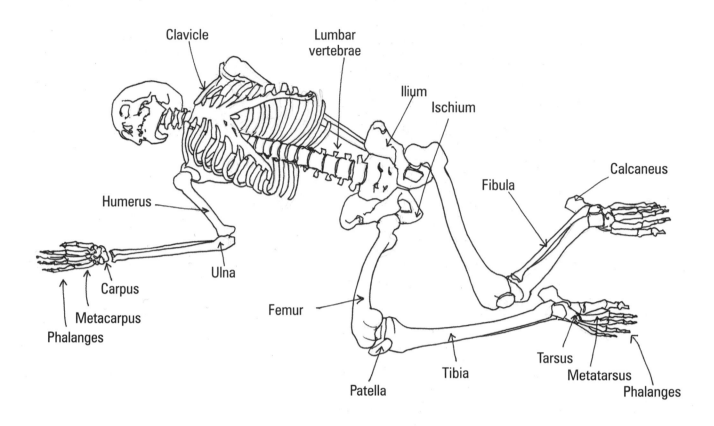

Clavicle

Lumbar vertebrae

Ilium

Ischium

Calcaneus

Fibula

Humerus

Ulna

Carpus

Metacarpus

Phalanges

Femur

Patella

Tibia

Tarsus

Metatarsus

Phalanges

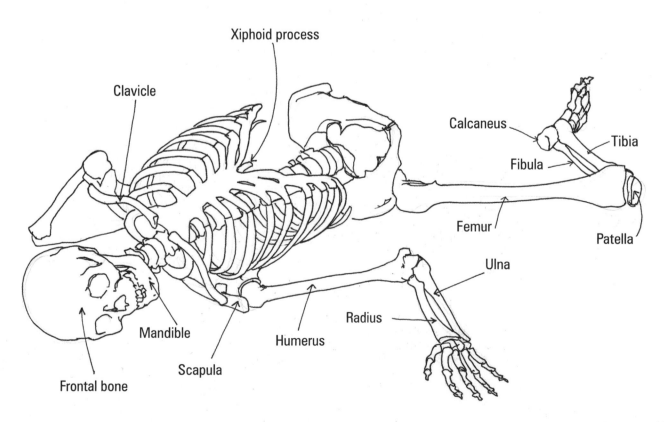

Xiphoid process

Clavicle

Calcaneus

Tibia

Fibula

Femur

Patella

Ulna

Radius

Humerus

Mandible

Scapula

Frontal bone

Plate 10: The Skeleton

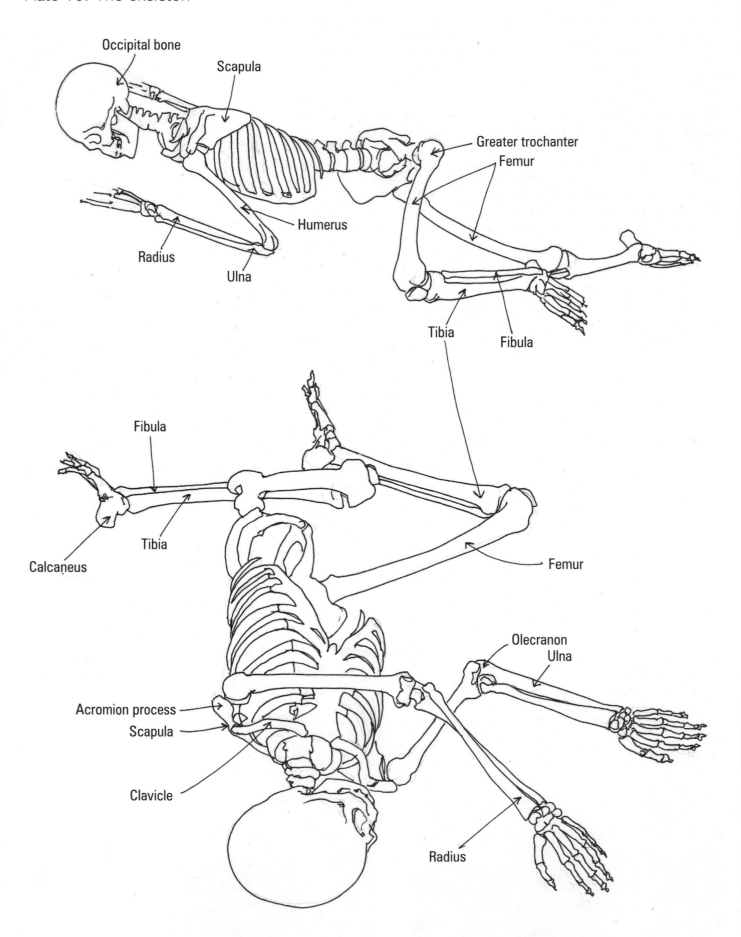

Occipital bone

Scapula

Greater trochanter

Femur

Humerus

Radius

Ulna

Tibia

Fibula

Fibula

Tibia

Calcaneus

Femur

Olecranon

Ulna

Acromion process

Scapula

Clavicle

Radius

PLATES 11 AND 12 (PAGE 22–23): THE MUSCLES

The skeletal muscles are the 'active' part of our body (or perhaps we should say, our locomotor system). When they contract, they act on the 'passive' part – bones – and move them within the limits permitted by the joints, enabling movements and poses. To a large extent, muscles help define the external forms of the body and, given that they shorten and enlarge during contraction, they cause the shape of the body to change depending on the action being carried out and its intensity. Because we have to choose certain reference points for evaluating the proportions of the model's body, we need to focus on skeletal elements rather than the muscles or the integumentary system (skin and other protective bodily coverings).

The skeletal muscles of most interest to the artist are situated on the surface, just beneath the skin, covered by tendon sheaths and connective tissue and, in certain regions, by a layer of fat. They are connected to the skeleton by tendons of different shapes, either cylindrical or flattened, but in any case almost incapable of being extended in order to be able to transmit the action of the muscle to the bones to which they are attached. In order to draw the human nude correctly, you need at least to be able to recognise the form of the largest or most evident surface muscles when at rest and when contracted, to be aware of their main action and to identify the tendons, which can emerge clearly during muscle contraction or be concealed by other neighbouring anatomical structures.

The muscles of the head are primarily important for chewing (masseter, temporal, etc.) and for facial expressions, produced by the cutaneous muscles above the facial bones (frontal, zygomatic, the orbicular muscle of the mouth, the orbicular muscle of the eye, buccinator, etc.). The prominent paired sternocleidomastoid muscle in the neck plays a very important role in determining its shape.

Some muscles situated near the surface of the back and chest (latissimus dorsi, pectoralis major, rhomboids, etc.) work on the upper limbs, while the trapezius, on the back and neck, also works by extending the head. The abdominal muscles (rectus, external oblique, etc.) make it possible to bend and rotate the trunk.

The limbs are the parts of the body most frequently represented in a variety of different ways and therefore have quite a well-known structure, as well as presenting the muscle masses most easily recognisable by the artist. The main shoulder muscle (deltoid) of the upper arm allows the arm to move forwards, backwards and to the side. The upper arm muscles make it possible to flex (biceps, at the front) and extend (triceps, at the back) the forearm, while the muscles in the forearm (very numerous, but grouped into a finger flexor group and a finger extensor group) determine the complex and variable masses during the various actions of the hand. The tendons of the finger extensor muscles fan out across the back of the hand.

The trunk and lower limbs are connected, superficially, by the gluteus maximus and the gluteus medius muscles. The muscles in the lower limb are arranged in a similar manner to those of the upper limb: the extensor muscles of the leg (quadriceps group) are positioned at the front of the leg, in the thigh; at the back we have the flexor muscles (femoral biceps, etc.); medially, the adductors and some others with a complex action (sartorius, gracilis, semimembranosus, semitendinosus, etc.). The most significant muscles in the leg are those which enable the plantar flexion of the foot (gastrocnemius and soleus, peroneus, etc.), which are situated posterolaterally, and the tibialis anterior muscle, which contributes to the dorsal flexion of the foot. As on the hand, the tendons of the toe extensor muscles are visible on the back of the foot.

Plate 11: The Muscles

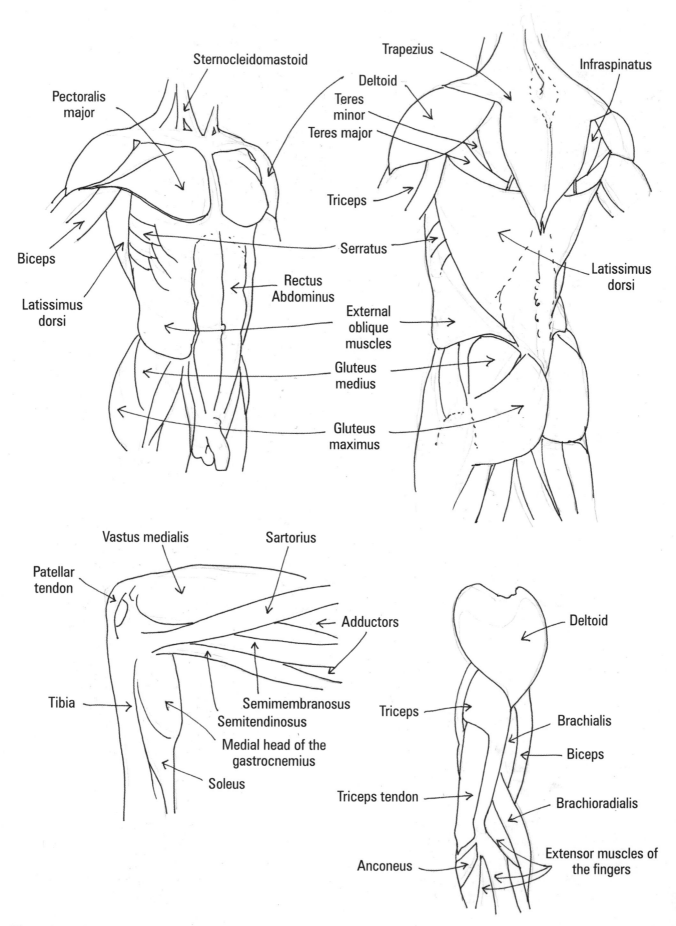

Sternocleidomastoid

Pectoralis major

Trapezius

Infraspinatus

Deltoid
Teres minor
Teres major

Triceps

Biceps

Serratus

Latissimus dorsi

Rectus Abdominus

Latissimus dorsi

External oblique muscles

Gluteus medius

Gluteus maximus

Vastus medialis

Sartorius

Patellar tendon

Adductors

Tibia

Semimembranosus
Semitendinosus

Medial head of the gastrocnemius

Soleus

Deltoid

Triceps

Brachialis

Biceps

Triceps tendon

Brachioradialis

Anconeus

Extensor muscles of the fingers

Plate 12: The Muscles

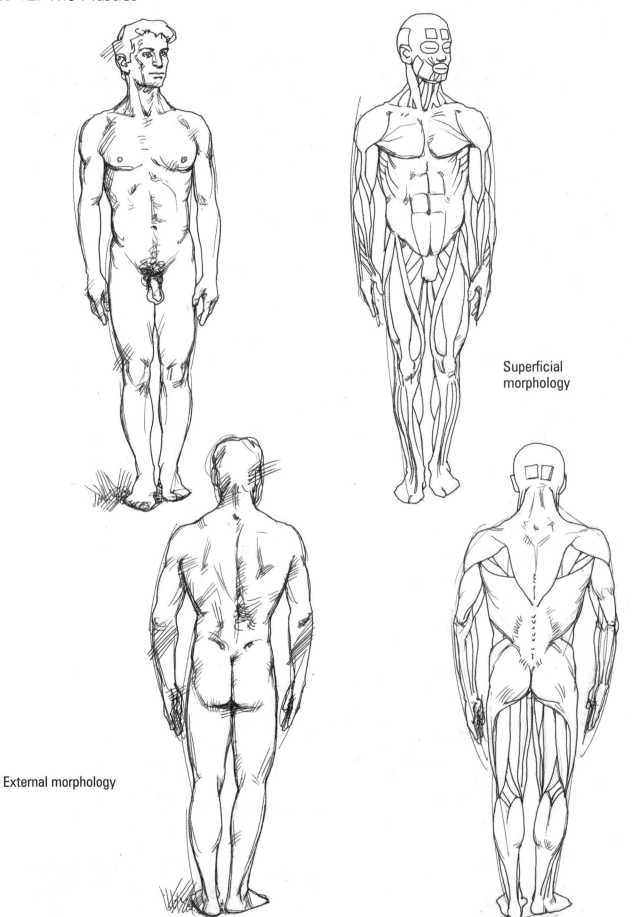

Superficial
morphology

External morphology

PLATES 13–15 (PAGES 25–27): MALE AND FEMALE BODY FORMS

In adulthood, the morphological differences between the male and female body are mainly to do with the skeletal structure, muscle volumes and the locations of the subcutaneous adipose (fatty) tissue and body hair.

By comparing the two skeletal structures, we can see that the woman has a smaller stature than the man (plate 14). The broader female pelvis and shorter but deeper rib cage, mean that the overall female form can be inscribed within an ellipse, while the male body can be inscribed within a triangle with the base at the top (plate 13).

The woman has a number of other characteristics that are evidently different from the man. For example, the woman has breasts, larger buttocks, more angled arms and thighs, shorter legs in relation to the trunk, more subcutaneous fat (back of the arms, thighs, abdomen, etc.), and less body hair (restricted to the armpits and the pubic region, where it ends horizontally) (plate 15).

Naturally, there are many other differences in the bones, musculature and morphology of the male and female body, but they are less significant and are sometimes linked to individual factors. Direct comparison and careful observation of models of both sexes, of different races and of various ages can be sufficient for the artist to gain an understanding of typical differences during the phases of growth, maturity and senescence (ageing), and to compare the variety of different bodily characteristics.

The differences between the male and female head deserve particular attention, especially as regards the bone structure (plate 14, bottom). In the man, for example, the head and face are longer, with more marked superciliary arches, a more inclined and receding forehead, and a stronger jaw line.

Plate 13: Male and Female Body Forms

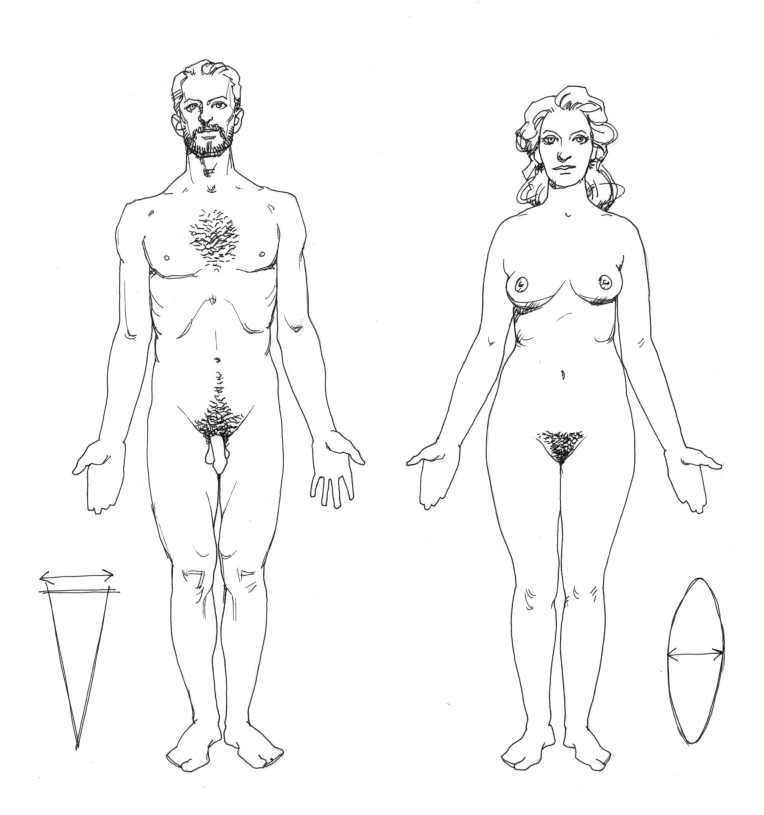

Plate 14: Male and Female Body Forms

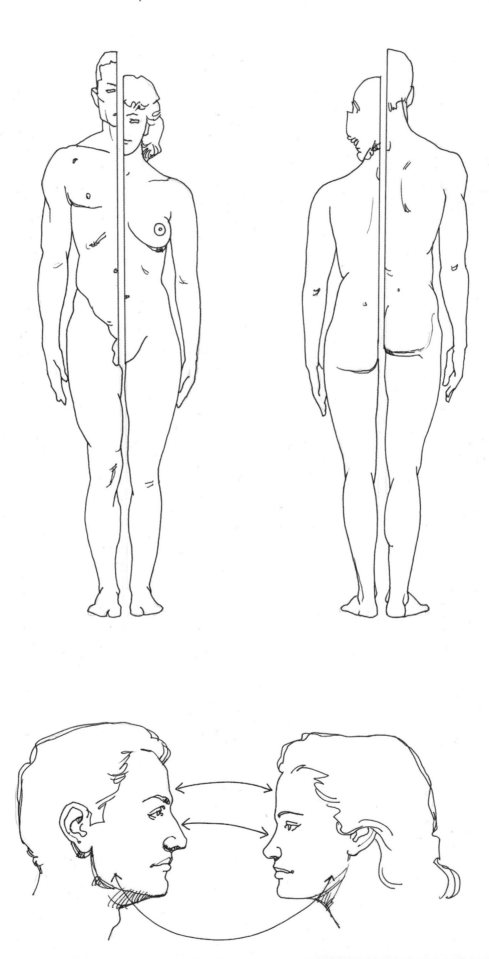

Plate 15: Male and Female Body Forms

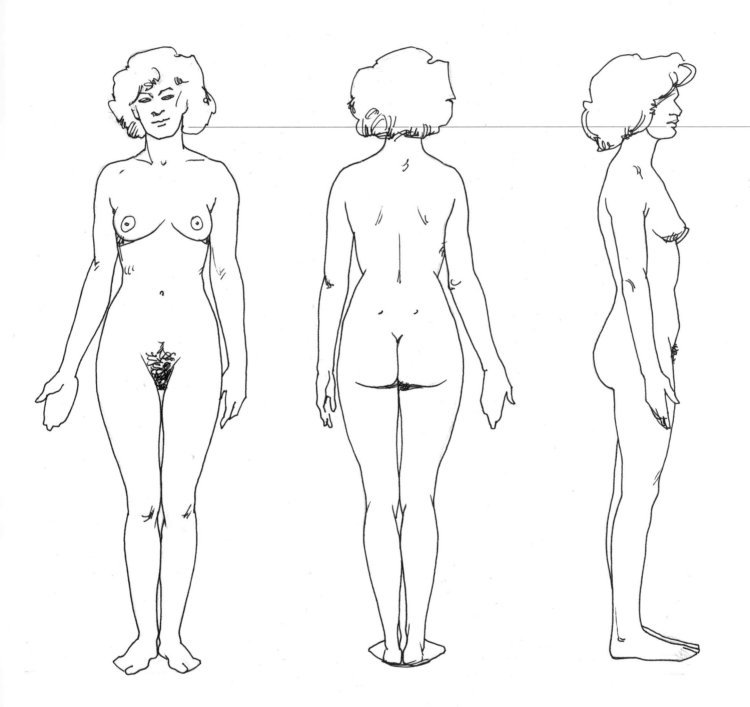

PLATE 16 (OPPOSITE):
ANATOMICAL STRUCTURE OF THE HEAD

To a large extent, the cranium determines the physical characteristics of the head because it is mostly positioned just beneath the skin, only separated from it by very slim muscles and a few thin layers of adipose (fatty) tissue. The skull (see also plate 8) is made up of two parts: the braincase and the facial bones. The braincase, or neurocranium, which contains the brain, is ovoid in shape (broader at the back and a little narrower at the front) and is formed by a few flat bones joined together (frontal, parietal, occipital) and by portions of other more complex bones (sphenoid, temporal). The facial skeleton, or splanchnocranium, is comprised of jointed bones with a particularly complex shape, destined to house sensory organs and the initial portions of the digestive system and respiratory system. As a whole, they determine the shape of the face, which is roughly pyramidal, and the individual features of different physiognomies, which it is so important to reproduce exactly when drawing a portrait. In fact, beneath the skin it is easy to perceive the frontal, nasal, zygomatic, maxila and, above all, the mandible bones.

With the exception of the temporal and masseter muscles, which help us to chew by causing the jaw to close, the muscles of the head are almost all orofacial (or expression) muscles, meaning that they are primarily subcutaneous (just under the skin) and act by moving the skin, shaping it to form the various facial expressions or carrying out certain functional movements (opening and closing the eyelids, the lips, etc.). In negative or aggressive expressions, the facial muscles work by contracting the lineaments, bringing them closer together in a threatening or defensive mask; in positive or joyful expressions, on the other hand, they cause the lineaments to broaden, expanding them into a mask of serenity or trust.

In order to draw the face effectively, as well as making close observations from life, it is also important to consider some anatomical and morphological differences between individuals from different races, but, above all, between the sexes. As a whole, and especially when seen from the front, the male face has an angular, solid, almost quadrangular structure, while the female face is more softly rounded, smaller in size and roughly oval. Naturally, there are also many other well-known differences, such as the presence of hair and the dimensions of the nose, the lips, the ears, the palpebral aperture of the eye, etc., but some are less distinct and less obvious. For example, the female forehead is more upright and regularly convex; in the man, the superciliary arch protrudes more and the curve of the nose is deeper; in the woman, the bridge of the nose is narrower, rectilinear or slightly concave; the male nose is more pronounced and protruding; the female eyebrows are thinner and regularly arched; the angle of the female jaw is wider and more rounded.

Plate 16: Anatomical Structure of the Head

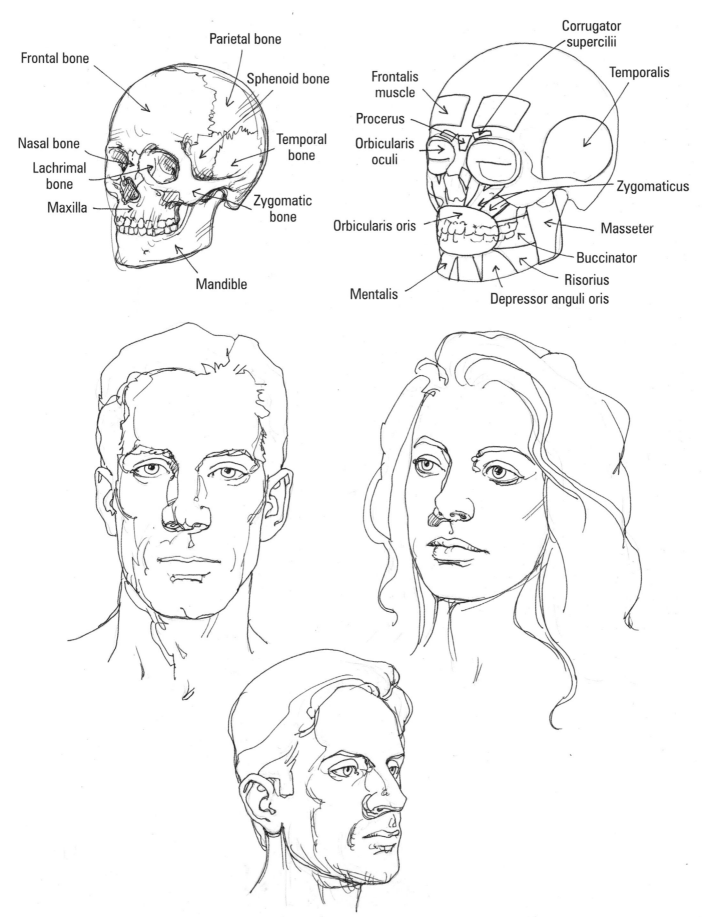

Frontal bone

Parietal bone

Sphenoid bone

Nasal bone

Temporal bone

Lachrimal bone

Maxilla

Zygomatic bone

Mandible

Corrugator supercilii

Frontalis muscle

Temporalis

Procerus

Orbicularis oculi

Zygomaticus

Orbicularis oris

Masseter

Buccinator

Mentalis

Risorius

Depressor anguli oris

PLATE 17 (OPPOSITE):
PROPORTIONS OF THE WHOLE BODY

Body proportions can be understood as the relationships between the various parts of a living being – the human body, in our case. In traditional Western thought, the concept of proportion is the most important factor in the perception of beauty, based on the choice of one part of the body (head, hand, etc.) as a unit of measurement to be placed in mathematical relation to the other body parts and to the body as a whole. A group of rules, or a 'canon', derives from these relationships. Many different canons have been formulated in the arts over the centuries, but they were rarely applied strictly by artists, instead being seen as an ideal and comparative measuring system in the observation of the real-life model.

Effectively speaking, the depiction of the figure is based on a canon that differs in relation to the specific style of each artist or the style prevalent during his or her period in history. A practical reference for drawing the adult male or female human body in an erect ('anatomical') position is given by the natural 'scientific' canon formulated in the 19th century following an extensive series of anthropometric statistical measurements, substantially confirming the most widespread canon in Ancient Greece and easily verifiable in normal life studies.

The chosen unit of measurement is the height of the head, from the chin to the top of the cranium. The height of the body corresponds to seven and a half times the unit of measurement, while the maximum width from shoulder to shoulder is equivalent to two units of measurement or three times the width of the face. The halfway height of the body is at around the level of the pubic symphysis in a man, and a little higher in a woman.

The grid of squares placed over the drawing of the figure provides a sufficiently clear illustration of how the proportional levels and the relative bodily reference points correspond.

While the 'scientific' canon indicates the average body height to be seven-and-a-half heads, that which best matches current aesthetic values and is easier to apply takes the stature to eight heads, while a more 'ideal' vision can extend it to over eight heads.

If the model assumes positions other than the erect position, this system is obviously more difficult to apply, but it can still be used as a reference point for checking any measurements made by eye, always referring to a chosen unit of measurement on the body, which may vary depending on the pose of the model, the artist's viewpoint or the artist's choice for that particular circumstance. That is to say, on a case-by-case basis it may be a measurement that is easier to take and compare than the height of the head, such as the length of the forearm or the foot, the width of a knee, etc. This measurement can then be compared to the other parts of the body that are foreshortened or less clearly visible.

Plate 17: Proportions of the Whole Body

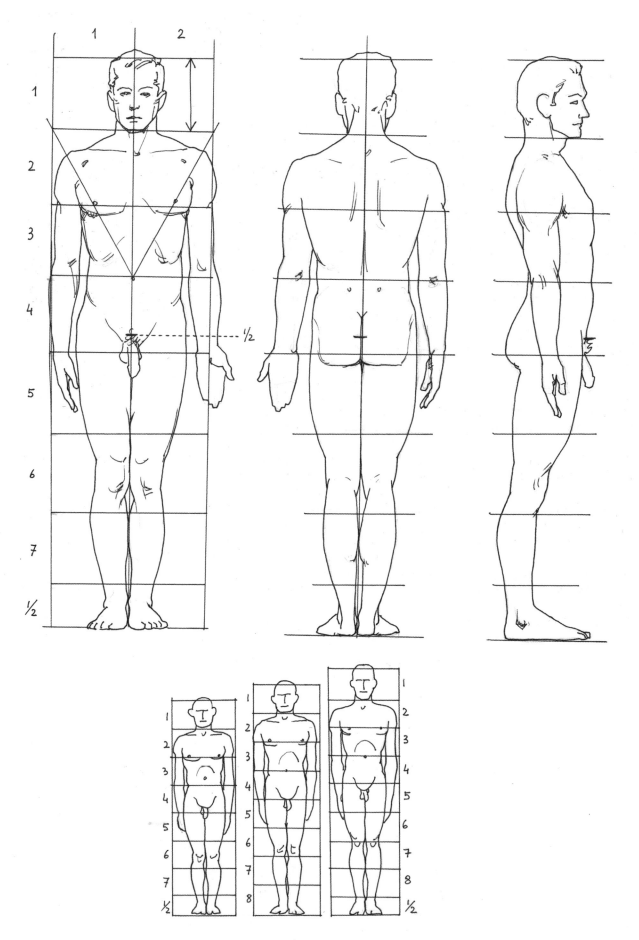

PLATE 18 (OPPOSITE): PROPORTIONS OF THE HEAD

When drawing a portrait, it is important to observe the overall form of the model's head closely, looking at the precise relationship between the parts that comprise the physiognomic traits. In fact, if the structural drawing places features in incorrect proportions or locations, even the most faithful depiction of details (eyes, nose, lips, etc.) will not provide satisfactory results in terms of creating a good likeness.

Heads, and especially faces, have highly varied morphological characteristics, although all can be traced back to standard relationships and distances that are very useful for the purpose of anatomical comparison and for checking the exactness of observation from life. For example, the height of the face (from the chin to the hairline) can be divided into three sections of equal height; the width of the mouth is equal to the distance between the pupils; the width of the nostrils is equal to the width of an eye and also to the space between the two eyes; the height of the ear is equal to the height of the nose and the angle of the two axes is parallel; the vertices of an equilateral triangle indicate the relative location of the outer corners of the eyes and of the indentation beneath the lower lip, while a similar triangle applied to the profile of the face will indicate the position of the chin, the ear hole and the superciliary arch.

The comparison between the height of the head, the length of the hand and the length of the foot, as well as the comparison between the length of the hand and other segments of the arm, or between the length of the foot and the length of the leg, can be very useful for checking that the proportions of these important parts of the human figure are correct.

PLATE 19 (PAGE 34): USING AN ARTISTS' MANNEQUIN

Both in terms of proportions and faithfulness to anatomical forms, a well-made, articulated mannequin can be very useful for studying the range of joint movements and learning the rules applicable to the living figure, even in the absence of a model. However, it is necessary to evaluate the orientation and maximum range that can normally be achieved by the joints in actual life and not to exceed them (except in the case of carefully thought out expressive accentuations), so as not to propose physiologically impossible poses.

Before a life-drawing session, you can use the mannequin as a reference to make some interesting comparisons of proportion, perhaps between the height of the trunk and the relative length of the upper and lower limbs, or by checking the posture of the 'Vitruvian' man by inscribing it in a circle, a square, a triangle, etc.

Plate 18: Proportions of the Head

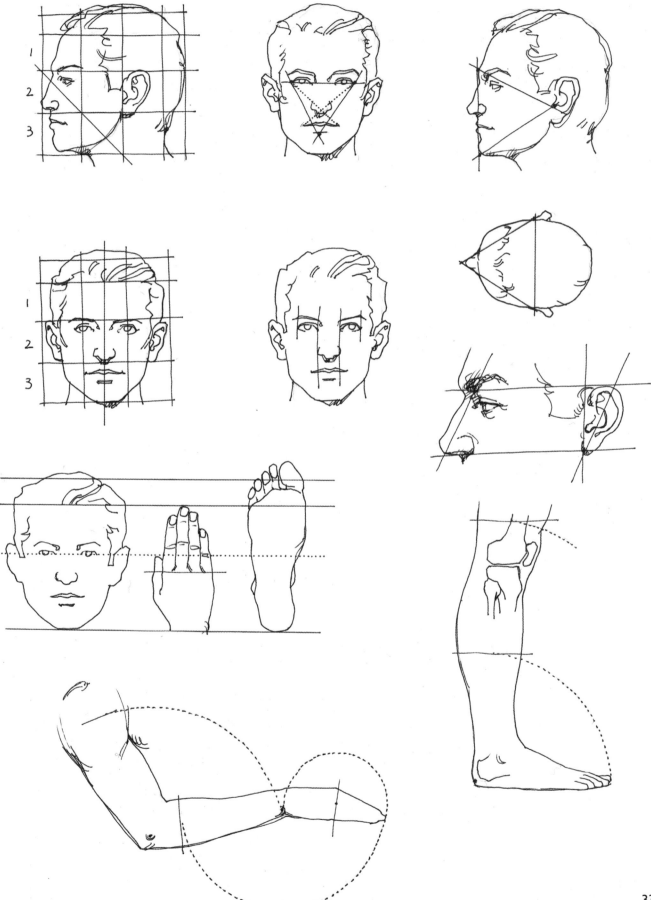

Plate 19: Using an Artists' Mannequin

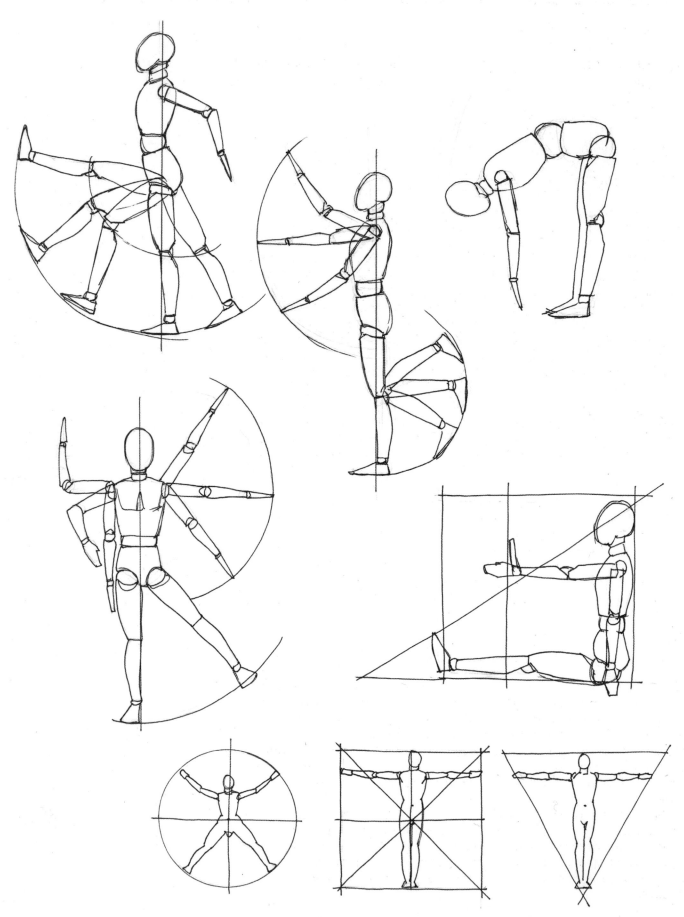

ANALYSING BODY STRUCTURE

'Things come first and names afterwards.'
Galileo Galilei

'Nature is something other than art.'
Gianlorenzo Bernini

PLATE 20 (PAGE 36):
SEEING THE GEOMETRICAL FORMS

Geometrical shapes have already been mentioned in the brief commentary accompanying plate 3. Here I wish to draw attention to the need to acquire a full understanding of the simplest and most essential characteristics of the forms the artist intends to use to express himself.

Breaking the figure down into solid geometric shapes – cylinder, cone, cube, sphere, pyramid, etc… (A) can initially be suggested and facilitated by using a mannequin (B). However, to be of any real educational use, this should always be used alongside a life model so that appropriate comparisons can be made. Reducing the figure to schematic geometrical shapes can clearly be used to represent the order of the various body segments observed in the erect human body viewed from side-on (C). This method highlights the order and relationship between the various axes of partial equilibrium (of the head, neck, chest, abdomen, etc.), according to which the verticality of the overall axis of equilibrium or the axis of the body as a whole is established. In this position, seen from the side, this axis can be projected on to the living figure as a vertical line passing just in front of the ear and the lateral malleolus on the ankle.

When observing the model in any pose, a highly simplified geometrical drawing can be used to identify the axes of the various body segments (head, trunk, limbs, etc.), making a full assessment of their spatial orientation in relation to the dynamic correctness of the main joints (D). However, it should be remembered that the axis understood as the line around which the flat geometric figure revolves to generate the solid (E), does not always correspond to the anatomical axis of the individual bones. For example, the anatomical axis of the femur does not correspond to the axis of the truncated cone used to indicate the geometric shape of the thigh. In figurative drawing, the axis of the geometric solid is primarily used to assist in the evaluation of the reciprocal relationship between the various structural parts of the body in terms of proportion and spatial orientation, providing an initial approximation of the volumetric masses, that is to say the amount of space occupied by them and by the body as a whole.

PLATE 21 (PAGE 37):
TRANSVERSE SECTIONS AND PROFILES

It is easier to perceive and assess the three-dimensional form of an object, especially the human body, if you learn to recognise the profile of the transverse sections (A). As well as having a certain degree of conceptual similarity to procedures used in map making (such as, isohypses or contour lines), these lines have much in common with anatomical histological section (study of cells using a microscope) and serial decomposition techniques, as well as the more recent computed axial tomography technique using a CAT scan (B). They are therefore indispensable for drawing the volumes (and not just the outlines) of such a complex figure as the human body effectively.

When drawing a heavily foreshortened figure (or parts of it), you can achieve a very convincing overall result if you are able to sense the actual form by reconstructing the 'lines' that wrap around it, extending them, if necessary, beyond the visible surface, as if the subject were transparent, (C). Like geometric simplification, this procedure not only facilitates the use of perspective, but also the 'construction' of the human figure in the mind, in any imagined pose.

Plate 20: Seeing the Geometrical Forms

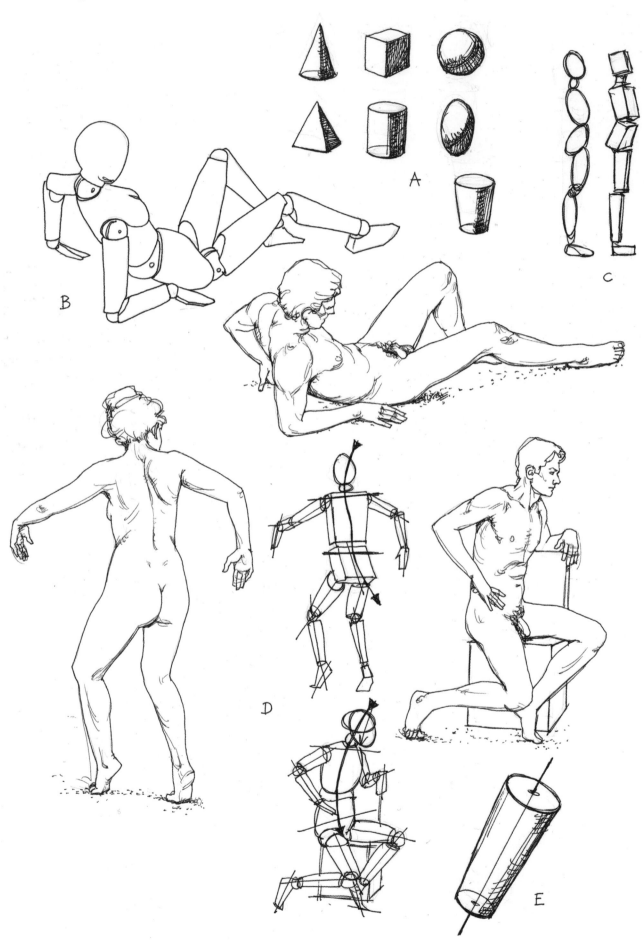

A

B

C

D

E

Plate 21: Transverse Sections and Profiles

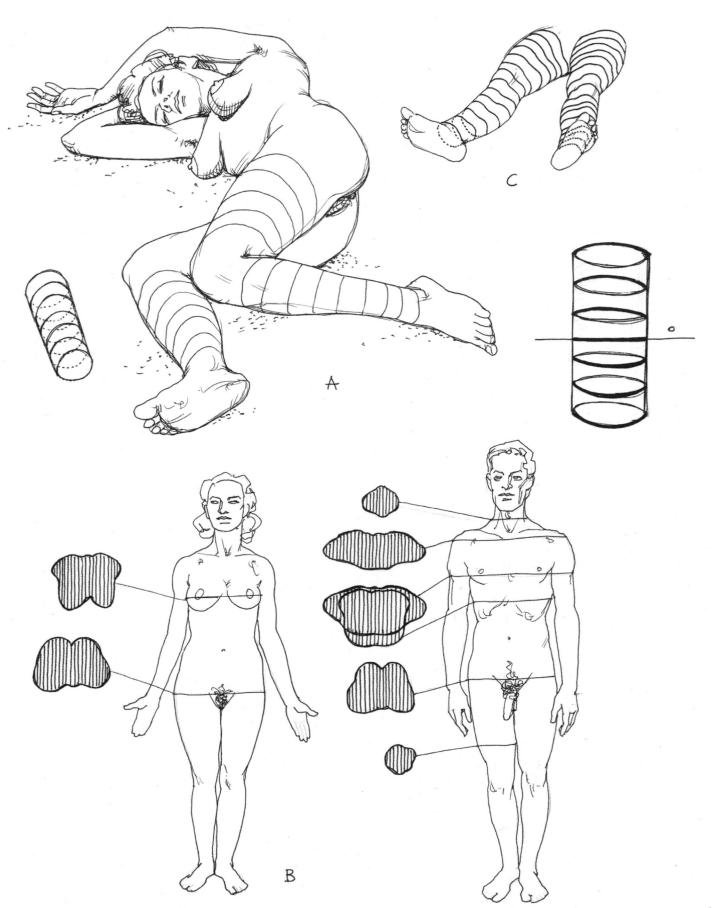

A

B

C

o

PLATE 22 (OPPOSITE): BALANCE AND FLOW

A number of interesting structural and transitional relationships become apparent when examining the profile of the whole body or the outlines of its individual parts. A single fundamental 'weight-bearing' line (usually corresponding to the head-spine-pelvis-lower limb group) characterises the pose of the figure in the simplest possible way (A), determining the rhythm of the body when seen together with other interweaving and overlapping lines (B).

The only symmetry found in the figure is frontal and bilateral and is known to be imperfect: neither half of the body ever exactly mirrors the other. The profiles of the two sides of the body never present identical convex or concave shapes at exactly the same level, either in the overall form of the body or in the progressively smaller forms of its various parts. Instead, the profiles alternate and follow after one another. For example, if we observe the lower limb from the side, it is easy to see that the broad anterior convexity of the thigh is countered by the more limited convexity of the posterior profile, while the same large anterior curve of the thigh finds visual and structural continuity in the equally accentuated convexity of the posterior profile of the calf. It is therefore possible to identify the flow lines (also known as continuity or wrapping lines) that connect the various body parts in order, through the muscle groups and joints, providing unity, continuity and structural dynamism at the same time (B).

In addition to this, contrast lines can be identified alongside the flow lines. These lines help to highlight the tensions, imbalances and differences between the forms and structures of the various body parts. In the whole 'counterpoised' body, this method makes it easy to identify the contrast lines created by the transverse axes at the levels of the shoulders and the pelvis (C). In the same way, we can also observe the alternating orientation of the transverse lines that can be traced at the levels of the shoulders, the elbow fold and the wrist on the extended arm (D). Naturally, similar observations can be made for other parts of the body, from any viewpoint and in any position.

Plate 22: Balance and Flow

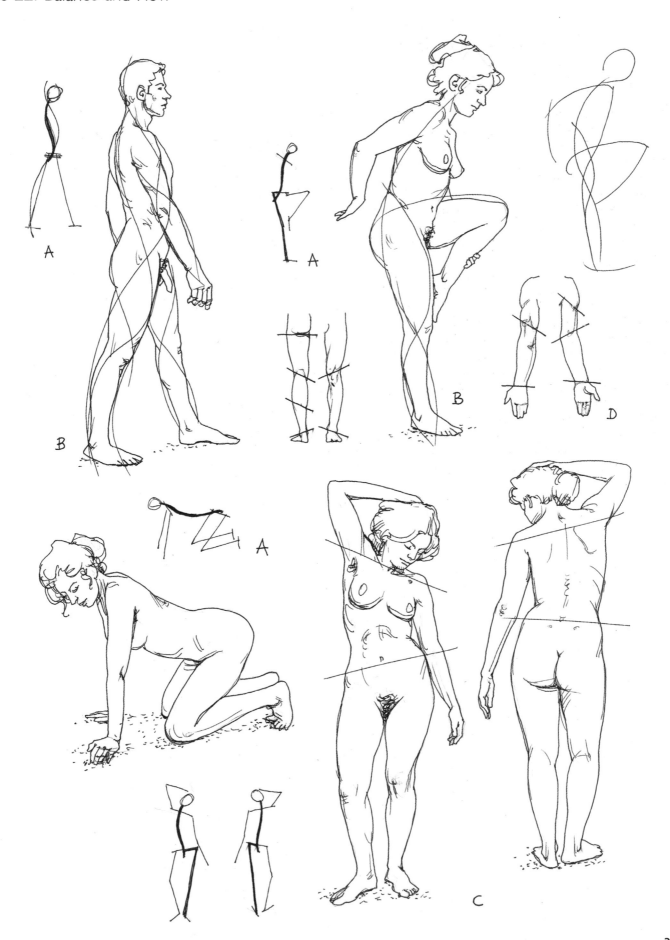

PLATES 23–27 (PAGE 41–45): GRAVITY, EQUILIBRIUM AND BALANCE

Earth's gravity acts as a single vertical downward force on the body, affecting the barycentre (or centre of balance), where the body's weight is most concentrated. The external forms of the human body are determined by its rigid support structure – the skeleton – and by tissues of various different consistencies, but mostly soft – skin, fat, muscles, etc. The force of gravity only modifies the skeletal relationships, causing the individual components to assume adaptations imposed by the position of the body (plate 23). The soft parts, on the other hand, undergo more marked modifications in shape, the extent of which is also linked to the model's body type. In women, these modifications are more obvious and easier to observe: the hair, the breasts and the abdomen, for example, expand, extend, move apart or rest on the trunk depending on whether the model is lying on her front or back, on one side or even standing on her head (plate 24).

In order to achieve equilibrium, the centre of gravity must fall vertically within the body's support base. So, in the erect figure, it must fall within the area occupied by the feet and the space in between them. In fact, in the majority of erect positions much of the body weight is concentrated near the heels, while the front of the foot expands the base of support. In variations on these positions, the body needs to balance itself by adjusting the way in which its various component parts (head, trunk, limbs) are oriented in space, thereby ensuring that the vertical centre of gravity falls within the base of support (plates 25 and 26).

The fairly spontaneous counterpoised position causes the skeleton to adapt in a particular way, with most of the body weight being transferred and concentrated on a single limb, the weight-bearing limb, which acts as a column, while the other limb flexes a little. This causes the pelvis to 'give' on this side, with the spine forming a compensatory curve in the opposite direction: the transverse axes at the level of the shoulders and the pelvis slant in opposite directions, and are no longer parallel as they would be in the erect position balanced on both the lower limbs (plate 27).

Equilibrium can be achieved spontaneously or voluntarily, depending on whether the body is static or in motion. It can be extended or modified by resting on external supports or by carrying weights. Moreover, the equilibrium of the human body can be stable when, by making a few minor adjustments, the body is able to restore the position of equilibrium from which it moved only slightly away. This is easy to observe in ourselves, or in the model when in an erect position, kneeling down, etc. Stability is obviously much greater if the model is seated or lying down, but in these cases we need to focus our attention on the variations in form of the body parts that are compressed against the rigid support or sink into the soft support.

Meanwhile, when in a state of precarious, unstable equilibrium, with a very small base of support (plate 25), the body tends to fall and has to make adjustments (spreading the arms, moving a lower limb away, moving the head, slanting the trunk, etc.) so as to preserve the equilibrium for even a short period of time. These adjustments require evident muscular effort.

Plate 23: Gravity, Equilibrium and Balance

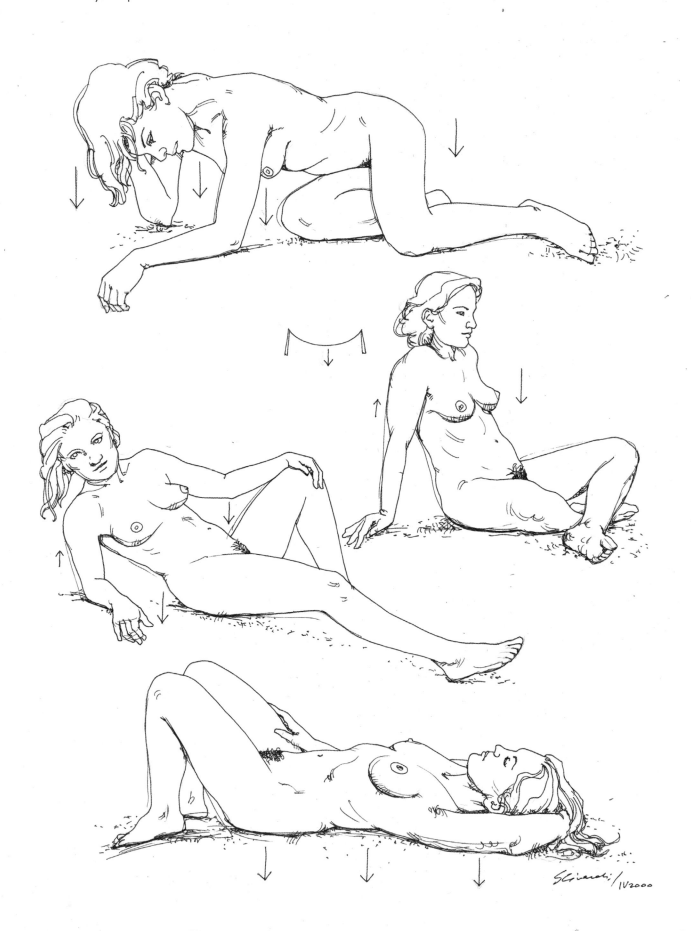

Plate 24: Gravity, Equilibrium and Balance

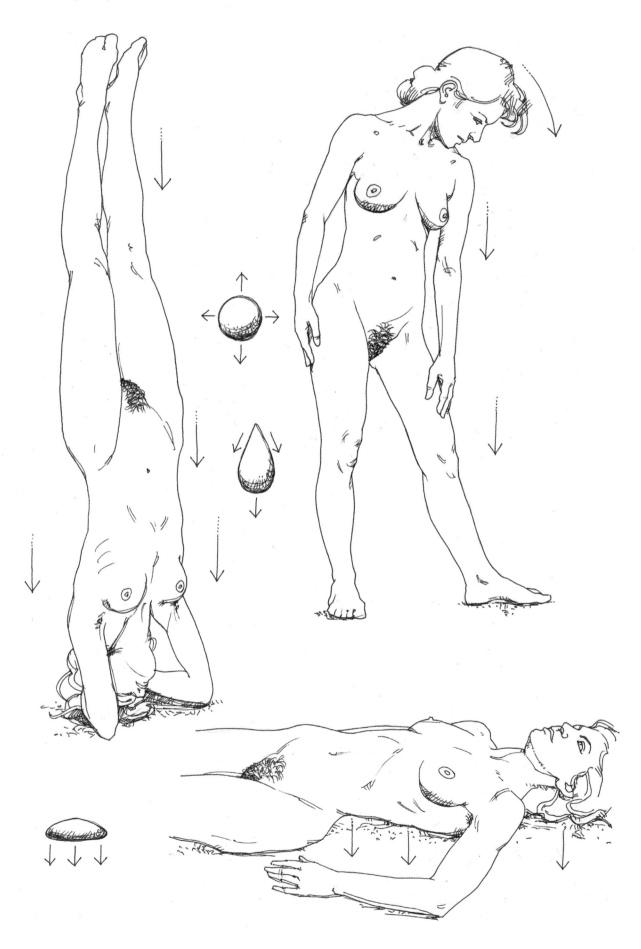

Plate 25: Gravity, Equilibrium and Balance

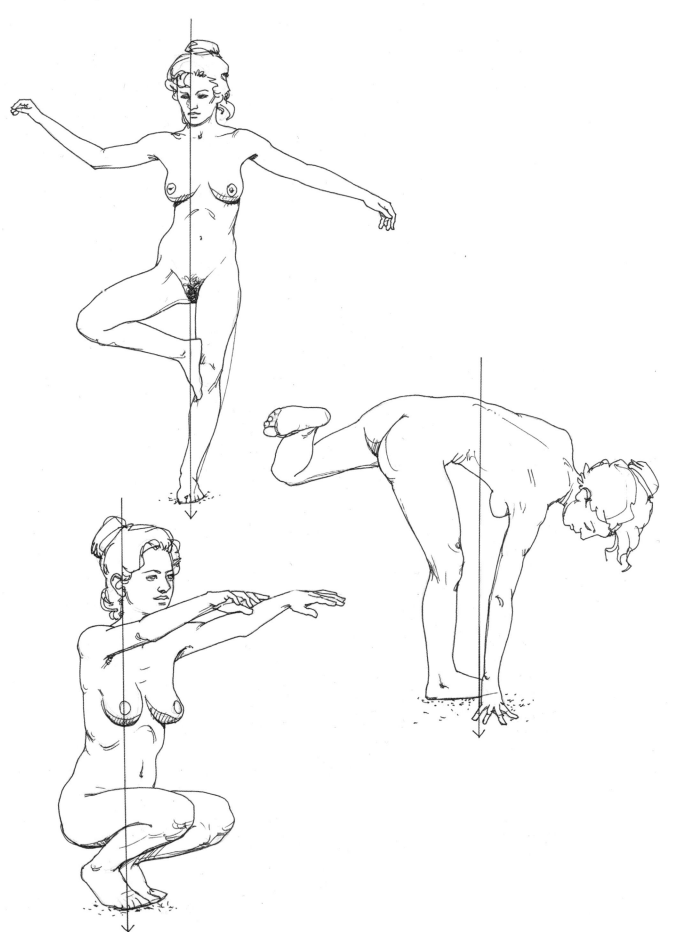

Plate 26: Gravity, Equilibrium and Balance

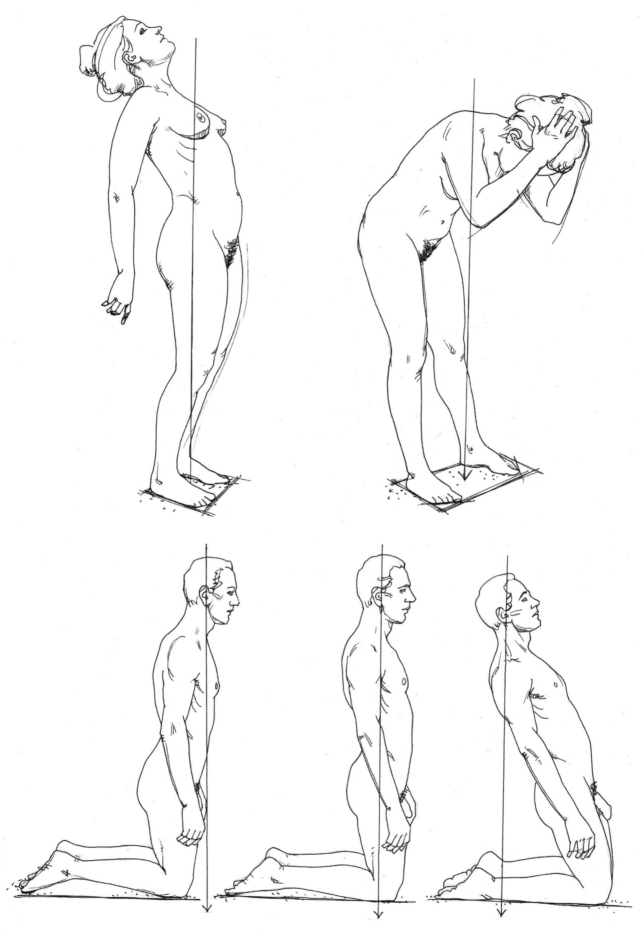

Plate 27: Gravity, Equilibrium and Balance

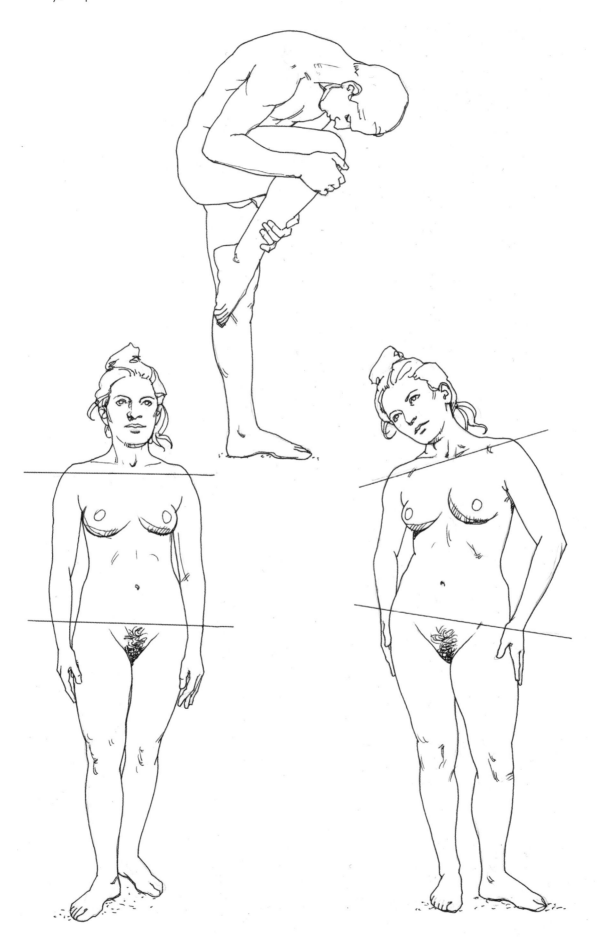

ORGANISING SPACE: PERSPECTIVE AND COMPOSITION

'Spontaneity is the fruit of conquest.'
Paul Valery

PLATE 28 (OPPOSITE): LINEAR PERSPECTIVE AND FORESHORTENING

Perspective is a graphic method used to represent spatial depth on a flat surface. There are various different methods of perspective (and it would be an interesting exercise to apply them in relation to the human figure), but since the 15th century, that most commonly used in the West concerns drawing the object as it appears to our eye, in its apparent form, that is to say by means of so-called artificial perspective. This is achieved using a linear procedure to obtain the sense of receding space, while also reducing the size of objects (which in this case are the parts of the human body) as they get further away from the viewer. In fact, the figure is almost always in conditions of perspective (foreshortened to varying degrees).

There are two recognised types of linear perspective. Parallel perspective (central and frontal) is based on the principle of the convergence at a single vanishing point (VP) of parallel non-vertical lines oriented towards the distance. The horizon line (H) always corresponds to the viewer's eye level and is determined by the viewpoint, that is to say the position from which the model is observed. Angular (or oblique) perspective, on the other hand, uses two vanishing points at either end of the horizon line (VP1 and VP2), where the non-vertical lines converge. This makes it possible to reduce the depth of the body and show it as foreshortened. It is easier to draw the figure in the right perspective if you imagine it within a solid geometrical outline, for example, a parallelepiped (a three-dimensional form created from six parallelograms) or a cube, or if you break it down into simple geometric forms (cones, cylinders, etc.) from which it is easy to achieve a good reproduction of the effective external morphology. Moreover, this method helps to prevent excessive deformations of the foreshortened body, which, even if depicted correctly in keeping with the rules of perspective, could be subject to a displeasing or unnatural-looking effect.

One aspect that must be considered when drawing the figure from life concerns the slight but evident effects of perspective deformation caused by the position and level at which the artist observes the model. In order to permit correct proportional assessment, the horizon line must be at the halfway height of the standing model (corresponding roughly to the pubic symphysis). The human eye is trained to compensate for perspective distortions (such as when we find ourselves too close to the model or when we observe a seated figure from standing, and vice versa), but difficulties can arise when reproducing these aspects faithfully in a drawing. For the same reason, the same critical attention should be paid when using photographs instead of a life model for a nude study or a portrait.

PLATE 29 (PAGE 48): TONAL PERSPECTIVE

Tonal (or atmospheric) perspective is a method that complements linear perspective. It faithfully translates the actual sensation of a progressive reduction in the strength and intensity of colours and tones with distance due to the effects of the atmosphere. This effect is particularly evident in open spaces, in the landscape, but can also be used and exploited to good effect in the depiction of the heavily foreshortened human body (A). A number of different tricks can be used. For example, as well as appearing to be larger in size, the parts of the body closest to the artist may also be drawn in more detail, using thicker and clearer lines, or modelled in stronger tones with more shading or contrast compared to the lines and tones used for the body parts that are further away and are reproduced using paler, slightly hazier lines.

Another effective method for rendering volume and the figure as it recedes into space is the partial overlapping of forms (B), almost forming a visual chain that links one form to another and arranges them in sequence within the spatial planes. This can be even more effective if the linear overlapping is strengthened by the projection of shadows thrown by individual parts on to adjacent parts.

Plate 28: Linear Perspective and Foreshortening

[H for horizon and V.P. for vanishing point]

V.P.1 V.P.2

H

V.P. V.P. V.P.

H V.P.

V.P. H

V.P.

H

H

H

H

H

H

47

Plate 29: Tonal Perspective

A

B

B

Plate 30: Unusual Viewpoints

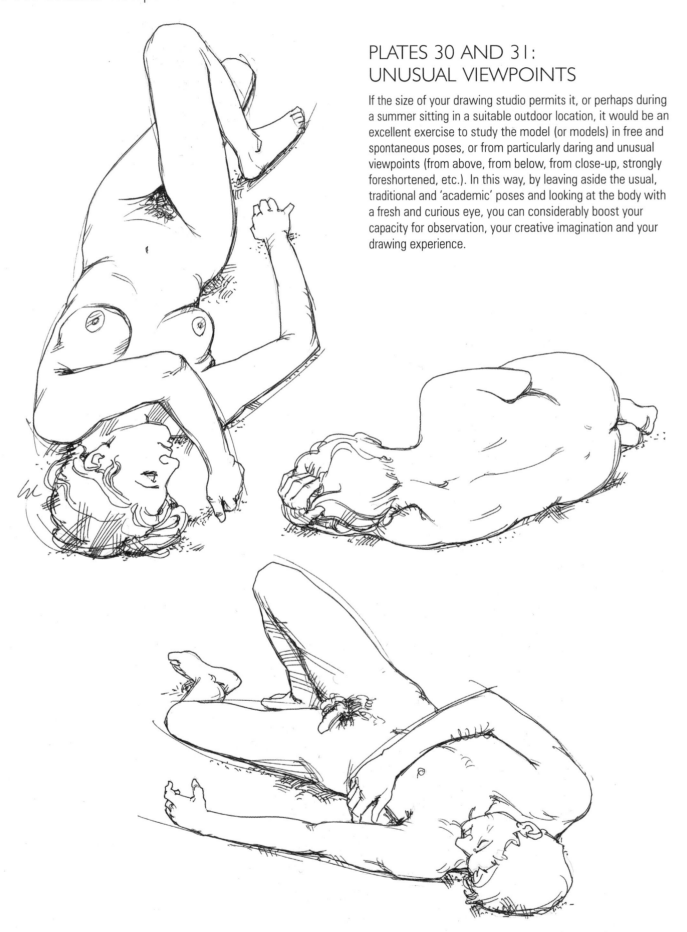

PLATES 30 AND 31: UNUSUAL VIEWPOINTS

If the size of your drawing studio permits it, or perhaps during a summer sitting in a suitable outdoor location, it would be an excellent exercise to study the model (or models) in free and spontaneous poses, or from particularly daring and unusual viewpoints (from above, from below, from close-up, strongly foreshortened, etc.). In this way, by leaving aside the usual, traditional and 'academic' poses and looking at the body with a fresh and curious eye, you can considerably boost your capacity for observation, your creative imagination and your drawing experience.

Plate 31: Unusual Viewpoints

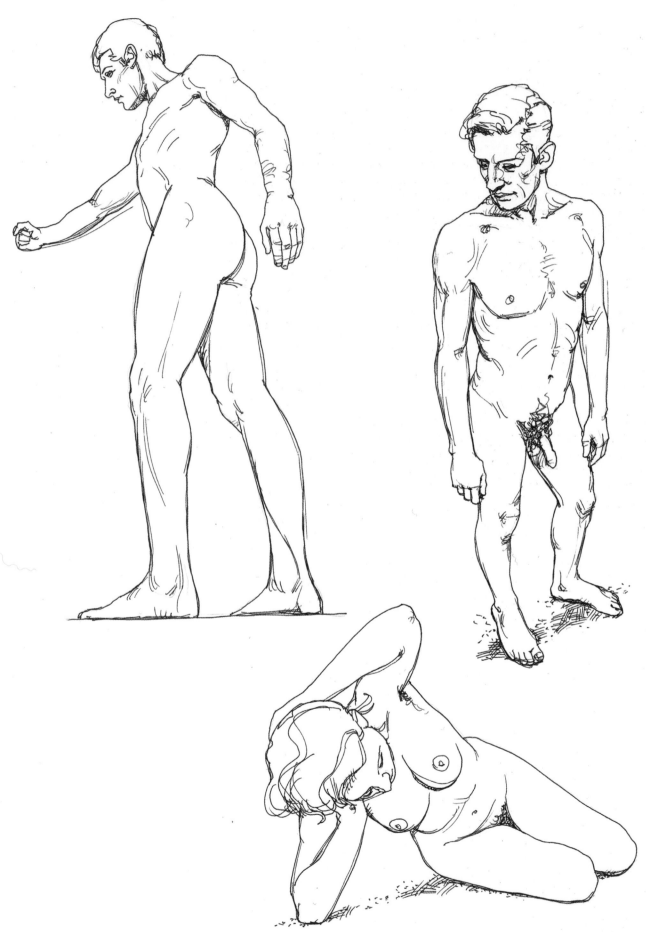

PLATE 32 (PAGE 52): PORTRAITS

The study of the human figure is not limited to nudes, but also involves examining the clothed body and, above all, working on portraits of the model's face alone or the whole body.

Composition is all about arranging the elements of the image you intend to depict on a surface (sheet of paper, canvas, computer screen, etc.). There are no clear-cut and binding rules (except, perhaps, that of the golden section), but instead a series of principles pertaining to our visual perception, for example those regarding unity, contrast and equilibrium, which I will come to again in relation to the next set of illustrations.

In portraits, a number of immediate decisions have to be made in terms of the composition: deciding whether to draw the whole figure, part of it or the head only and, in this case, establishing whether to draw it from the front, as a profile or a three-quarter view; deciding whether to place the model in a setting or to isolate him or her against a neutral background; deciding on the dimensions and the format of the drawing, whether to extend it horizontally or vertically, etc. Experience counts for a lot when making decisions of this kind.

Here are a few useful guidelines:
- Frontal portraits are best composed with the head not right in the centre of the sheet but a little higher, leaving equivalent spaces at the sides while not allowing the top of the head to get too close to the edge of the sheet.
- In portraits showing the face at an angle, such as the three-quarter view, it is best to leave a larger space between the front of the face and the edge of the sheet, rather than between the back of the head and the edge (A).
- Profile portraits are more effective if you leave a large space in front of the face, while making sure you do not 'cut' the rear profile of the head or cause it to coincide with the edge of the sheet (B).
- A close-up portrait of the subject (face or figure) can suggest strength, authority and security (C).
- A very suggestive and unusual effect can be achieved when the face occupies the entire surface of the sheet (D).
- The background does not necessarily have to extend to or correspond with the whole surface of the sheet: it can be more limited and the figure may overrun the edges to create unusual and interesting graphic and compositional effects (E).

Plate 32: Portraits

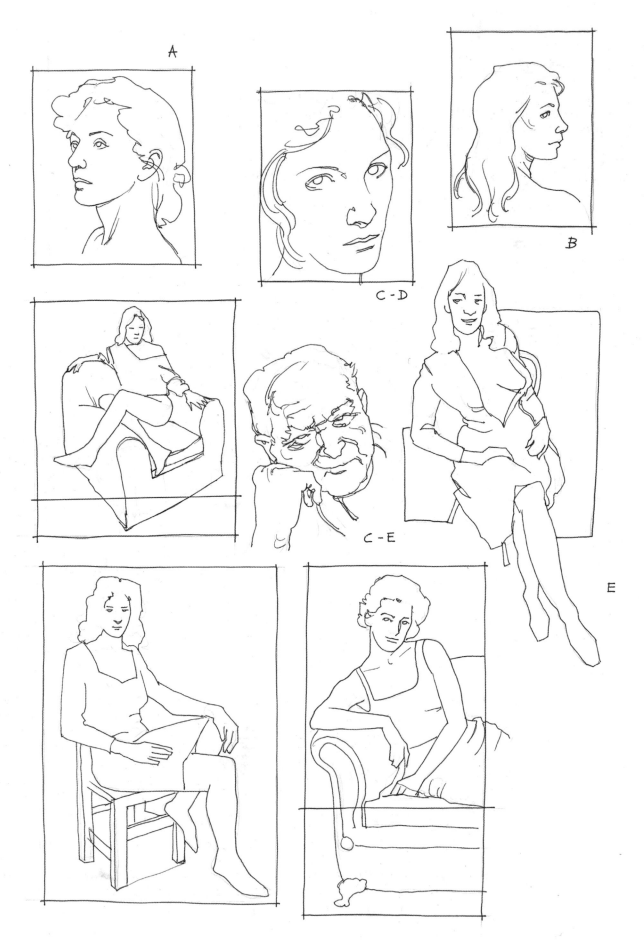

PLATE 33 (PAGE 54):
COMPOSITION, FRAME AND FORMAT

In painting and drawing (and photography too), composition consists of choosing and arranging the expressive elements to be depicted on your chosen support. Much of the composition depends on the artist's intuition and visual training and is not subject to set rules. In fact, there are many exceptions to the well-known rules applied frequently in art over the past few centuries, meaning that they are only useful as a rough guide. These rules include: the golden section; the S curve; leading lines; the arrangement of elements in circles, triangles or diagonals, etc.

It is actually more beneficial to examine the composition of historic works of art, especially those subsequent to the introduction of photography and film in artistic expression. It is also worth doing some experimental research in order to come up with some principles (in terms of units, contrast, equilibrium, convergence, dispersion, etc.) and styles that best meet the requirements of the setting and the subject.

In figure drawing, the arrangement and pose of the model and the chosen viewpoint have a decisive influence on the 'frame' of the image (that is to say the space that the figure, or part of the figure, is destined to occupy on the surface) and the format (the dimensions of the support and its basic shape – square or rectangular, extending vertically or horizontally).

PLATES 34 AND 35 (PAGES 55–56):
CHOICE OF POSE AND VIEWPOINT

When drawing a figure from life, it is important to walk around the model and assess him or her from different potential viewpoints, gaining an understanding of the various aspects and developing the most suitable and satisfactory depiction in the most appropriate composition.

The choice of the pose to be assumed and maintained by the model is essentially linked to the artist's expressive aims and aesthetic intuitions. The choice of viewpoint, on the other hand, is made after the pose has been chosen and should exploit the most significant and specific characteristics by depicting the most interesting and attractive aspect overall. As in the case of the composition, this choice is not guided by rules, but instead by an awareness enriched and refined by means of careful and intelligent exercises in observing the model and by the critical examination of historic and contemporary paintings and sculptures. Although subjective, the choice of pose and viewpoint are good when they succeed in appropriately conveying an interesting aspect of the structure, the character or the spatial positioning of the model. For example, in plate 34, both the male and female models remained motionless in the chosen pose, but I drew them from different viewpoints by walking around them. Sketch 3 expresses the 'triangularity' of the composition, evoked in full by the profiles of the figure seen in its most extensive lateral projection; sketches 1 and 2, on the other hand, focus on the 'gesture' of the model, each in a slightly different way. In sketch 1 the pose appears to be explicit and dynamic, while in sketch 2 the model seems to have been surprised during the gesture, which becomes more significant in the better volumetric composition of the body.

Sketch A of the male nude looks static and features a few technical problems in the foreshortening of the right thigh. By drawing the figure from a standing position (sketch B), rather than seated, I managed to improve the perspective and achieve a greater sense of tension in the pose. Sketch C changes the expressive meaning radically: the view of the back and the unfurling of the powerful musculature added a touch of vigour and pride to the fairly static and relaxed position expressed by the frontal view.

In plate 35, as well as observing the model from different viewpoints, I also made some slight changes to the chosen pose in order to achieve the result in sketch 4. In the other three sketches, it is clear that the viewpoint fails to do justice to the model's body, which actually appears awkward in sketch 2, a little coarse in sketch 3 and almost sculpturally insignificant in the frontal view (sketch 1).

Plate 33: Composition, Frame and Format

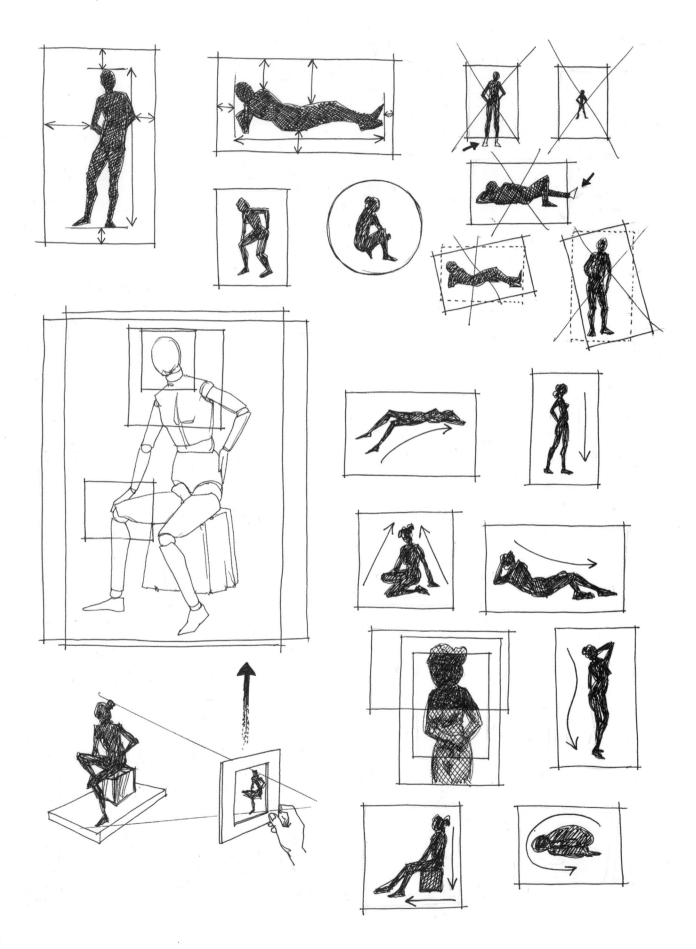

Plate 34: Choice of Pose and Viewpoint

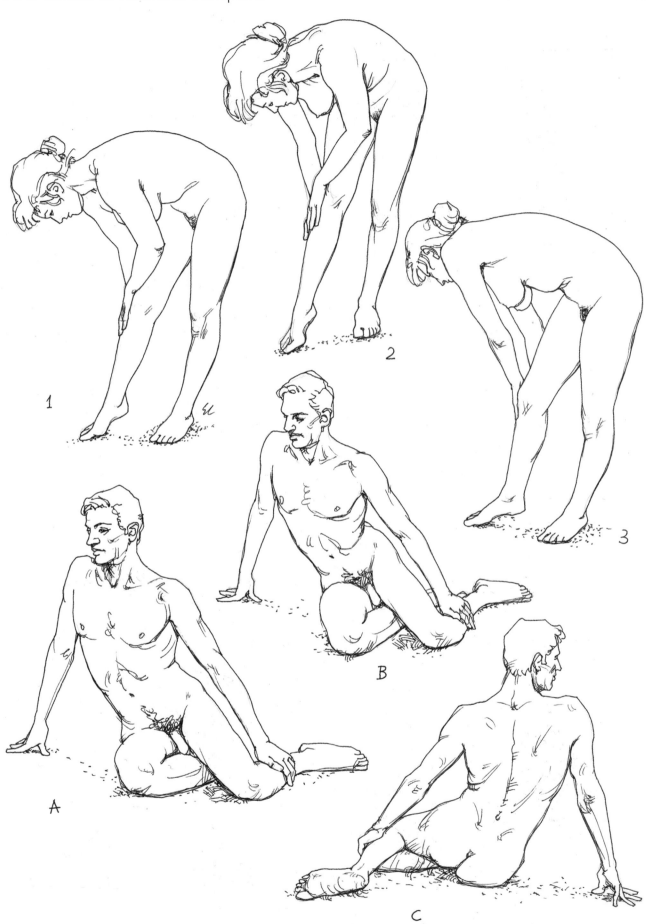

Plate 35: Choice of Pose and Viewpoint

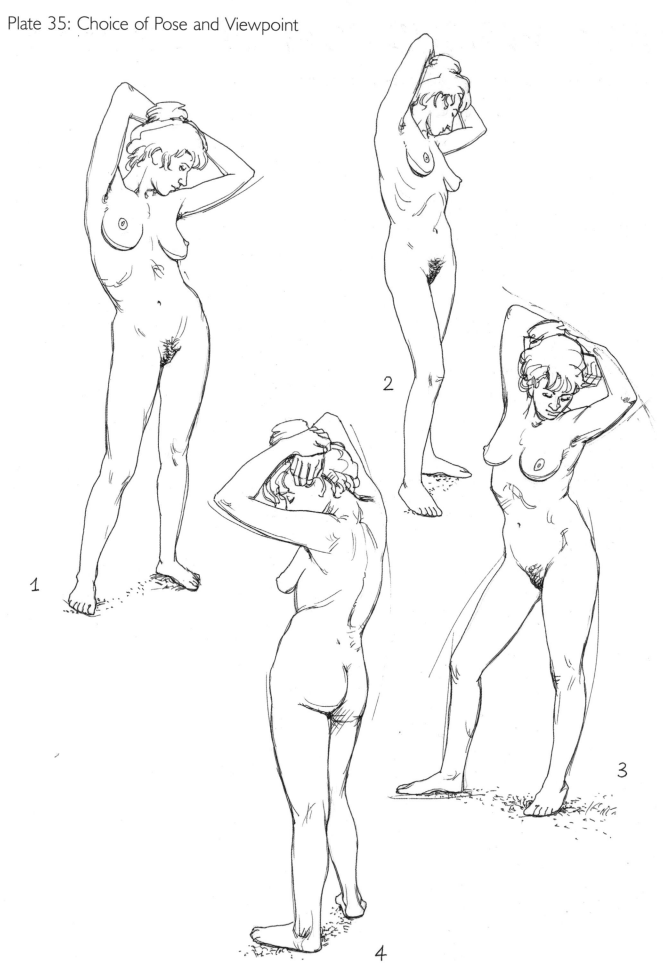

STATIC VERSUS DYNAMIC POSES

'Only an exhaustive analysis can be transfigured into a sublime synthesis.'
Enrico Vannuccini

PLATES 36 AND 37 (PAGES 58–59): STABLE, STATIC POSES

The human body is designed, first and foremost, for movement and action, and it is particularly important to convey this sensation of vitality, even when drawing, painting or sculpting static poses that suggest the stability of the body.

'Static' here refers to poses in which the body is in a state of stable equilibrium, while 'dynamic' refers to the body in motion or in a state of precarious balance. As we all know, the most stable position is achieved when the barycentre of the body is positioned very low down, with quite a large base of support, and the body gives in to the force of gravity. The term 'pose', which is used to describe the position assumed by the model for the artist so that he or she can be studied and depicted, suggests a position of stillness, which can be maintained without difficulty for a certain period of time. Typical static positions include erect poses with an external support, seated poses and reclining poses as long as a state of stable equilibrium prevails, because otherwise there is a hint of tension and incipient motion which could cause the pose to be classified as dynamic, at least in perceptive terms. In fact, the concepts of 'static' and 'dynamic' considered here have a much broader meaning than the same terms used in physical mechanics because in art they also involve subtle psychological and emotional sensations. In a perfectly static pose, like the ones in plate 36, the body is completely abandoned to the force of gravity, which pulls it towards the ground (on which it effectively rests), producing a 'compression' of its various parts, one on top of another.

In the drawings in plate 37, on the other hand, the static nature of the poses is weakened a little by the hint of muscular tension, asymmetry and careful control over the pose.

Plate 36: Stable, Static Poses

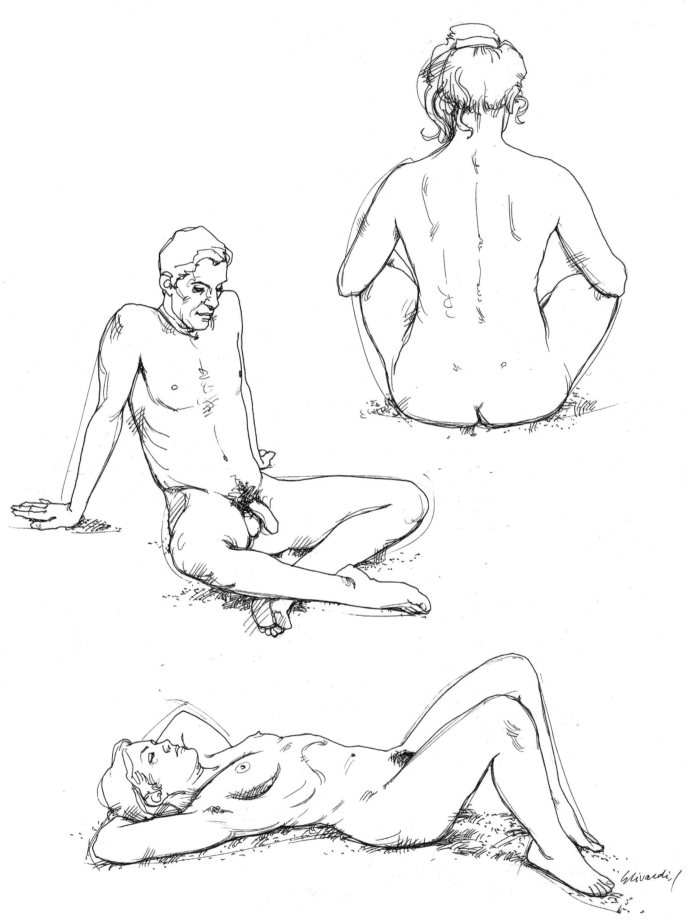

Plate 37: Stable, Static Poses

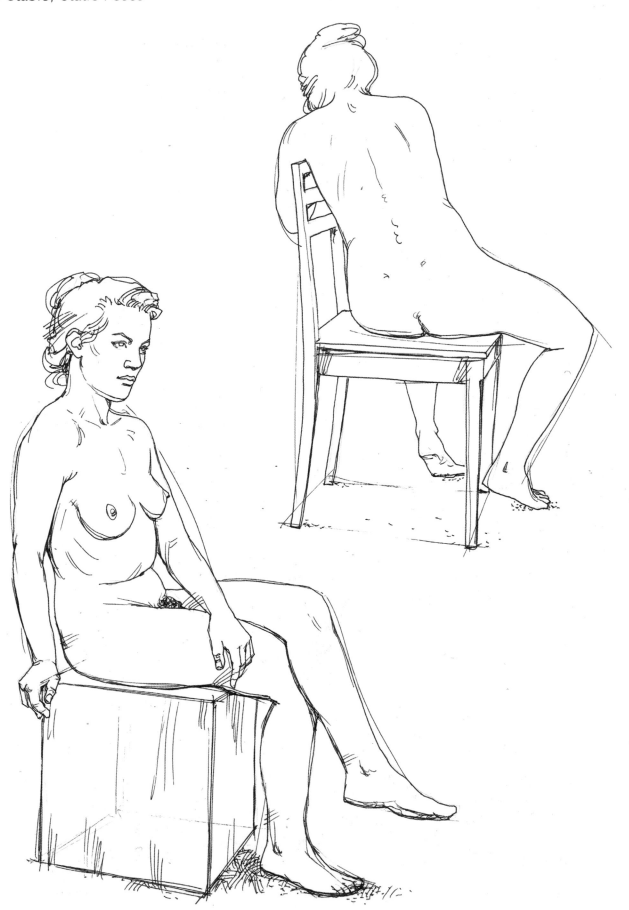

PLATES 38–40 (PAGES 61–63): STANDING, SITTING OR RECLINING POSES

The comments accompanying plate 5 mentioned the necessity to identify the 'character' of each figure we are drawing. In these illustrations we propose looking for the dominant 'tendency' in certain types of poses that are often chosen for the study of the human figure. The erect position (plate 38) suggests verticality, the stacking of the weights of the individual body areas, each in close relation to those beneath so as to permit the equilibrium of the whole body. The seated position (plate 39), which can assume more complex and varied forms, sometimes suggests enclosing curves, angles or diagonals in the reciprocal relationships of the trunk, limbs and support. The reclining position (plate 40) suggests the horizontality of the axis of the whole body, contrasting the verticality of the pelvic or shoulder axes and adding tension to a pose of absolute stillness.

The identification of these fundamental tendencies, associated with those inspired by the forms of the individual body parts, can facilitate the composition of the drawing, the rendering of the spatial relationship between the figure and the setting, the positioning of tonal contrasts, and the choice of optimum format (square, round or rectangular support, etc.).

PLATE 41 (PAGE 64): TENSION, RIGIDITY AND FLEXIBILITY

The skeleton is the static, passive, supporting component of the human body. In visual terms too, it is associated with rigidity and is not in fact subject to deformations, stretching or compression as a result of movement. It can be clearly perceived in numerous specific parts of the body, where it is located just beneath the skin.

The muscles are the active, dynamic component of the human body. When they contract, they move the bone segments to which they are attached (within the limits permitted by the joints) and, together with the integumentary system (skin, adipose tissue, glands, hairs, etc.), they contribute to the effective external form of the body.

For the artist, the skeleton can therefore be associated with the characteristic of rigidity, while the muscles and integumentary system can more appropriately be associated with the characteristic of flexibility. The skeleton, muscles and integumentary system combine to produce movement – torsions, rotations, flexions and extensions move some parts of the body away from others or bring them closer together, creating tension and extension on one side of the body and causing the contraction of the opposite side. On the tense side it is usually also possible to observe the skin stretching and the muscles being flattened against the skeleton, while on the contracted side folds form in the skin and adipose tissue.

When drawing a figure in action or in any pose implying tension, it is essential to observe the exact position of the pelvis and spine because this is the only way to interpret the movement, with the positions of all the other body parts adapting to it. It can sometimes also be useful to identify the flow and contrast lines (plate 22).

Plate 38: Standing Poses

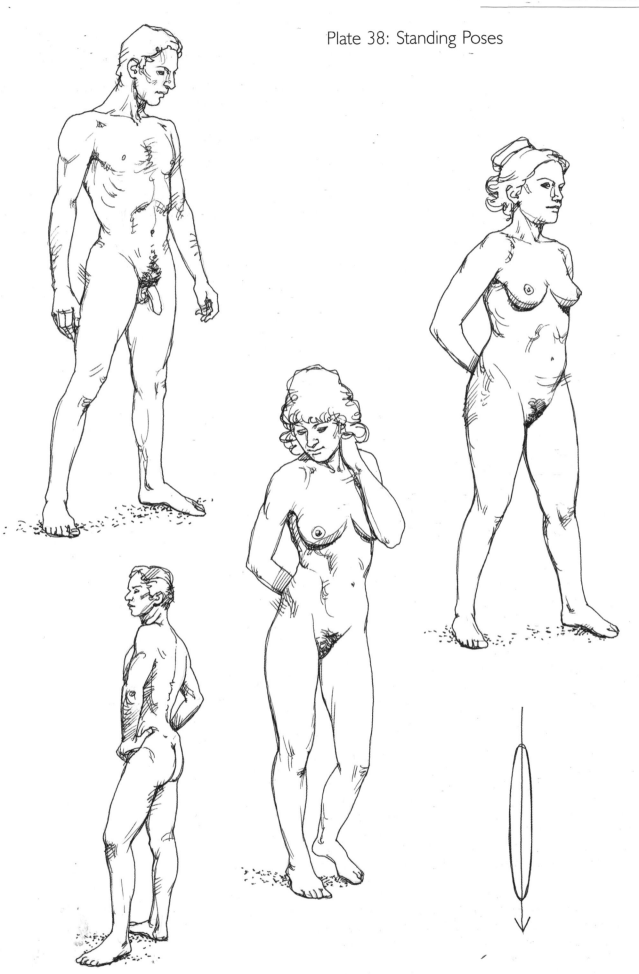

Plate 39: Standing Poses

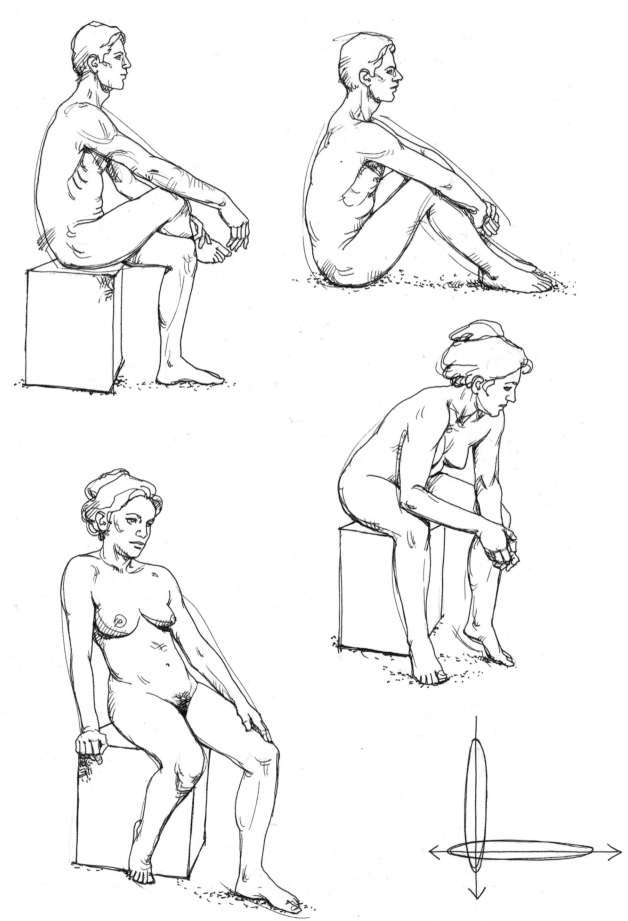

Plate 40: Reclining Poses

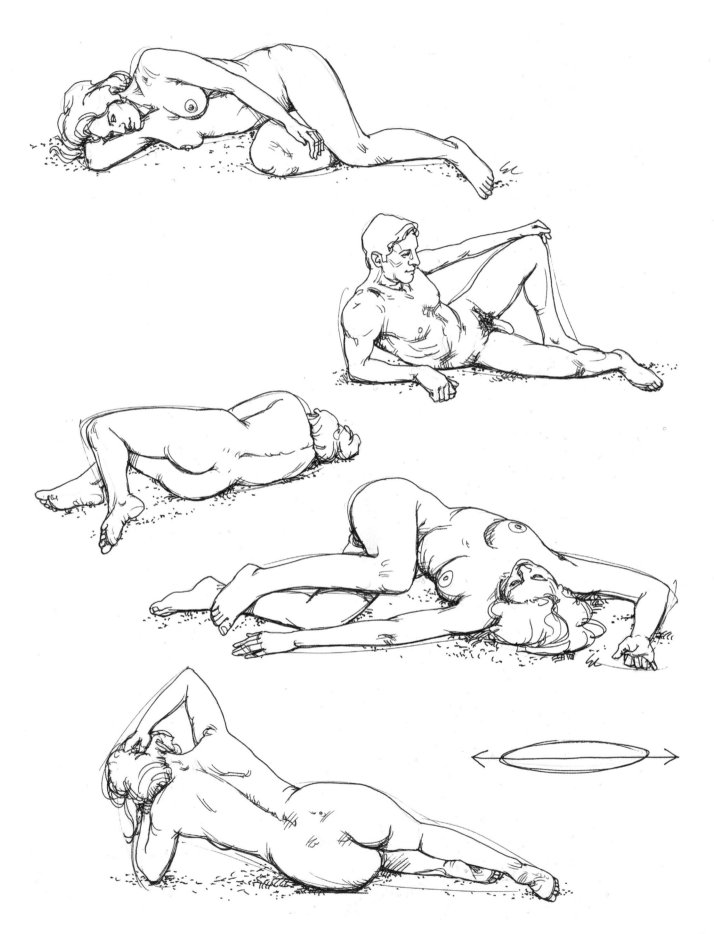

Plate 41: Tension, Rigidity and Flexibility

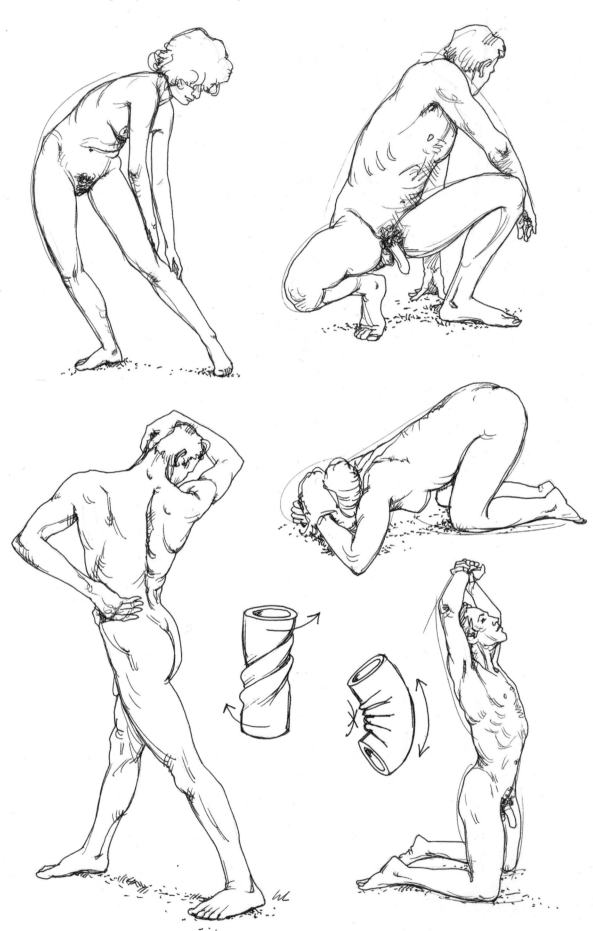

PLATES 42 AND 43 (PAGES 66–67): UNSTABLE AND DYNAMIC POSES

The human body can easily find itself in positions of unstable equilibrium because the natural base of support (the area occupied by the feet) is quite small and every movement of the body segments above forces the entire structure to adjust in order to restore the equilibrium. This is achieved through gradual, calibrated orientations of the upper limbs, the head and the lower limbs through space, in order to support or counterbalance the trunk (chest, abdomen, pelvis). For example, if the model stands on one foot or on tiptoe, the equilibrium will be particularly unstable and it will only be possible to maintain this position for a short time. Intense muscle contractions are observed not just in the weight-bearing limb (or limbs), but also along the entire chain of muscles that permits that particular pose.

In order to draw figures in precariously balanced positions effectively, it is important to observe them very carefully before making the first marks on the paper and then to define the position of the pelvis and its relationship to the whole spine straight away, identifying the main flow line, such as that which connects the trunk to the weight-bearing limb and continues down to the ground (see plate 22). Looking for these structural elements of the figure is even more important in sculpture and modelling (building the armature), although it comes almost spontaneously to those who, working in these fields, have to ensure that their work is balanced and stays upright thanks to the correct reproduction of volumes and three-dimensional masses.

Plate 42: Unstable and Dynamic Poses

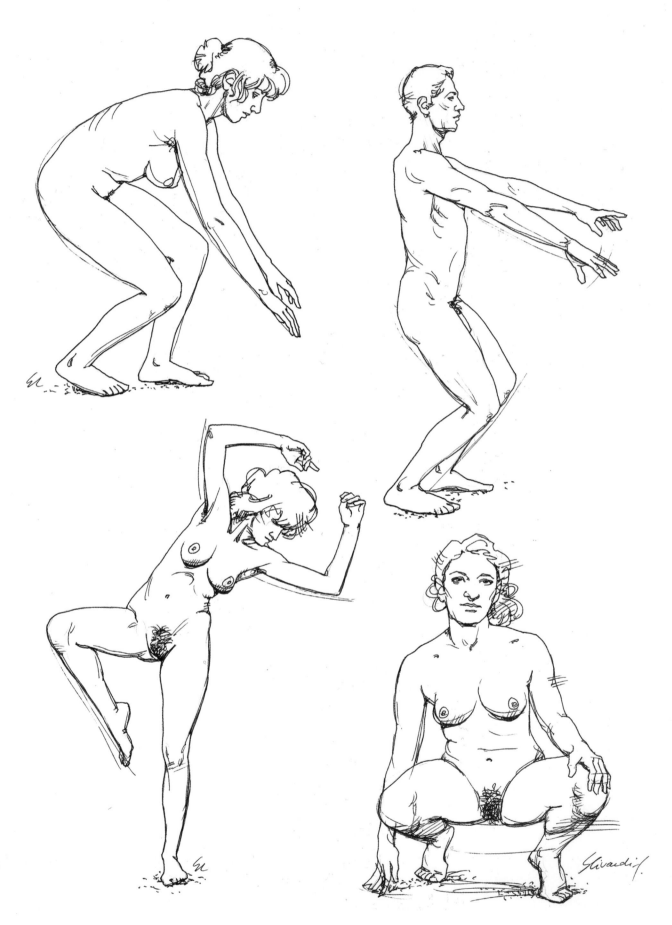

Plate 43: Unstable and Dynamic Poses

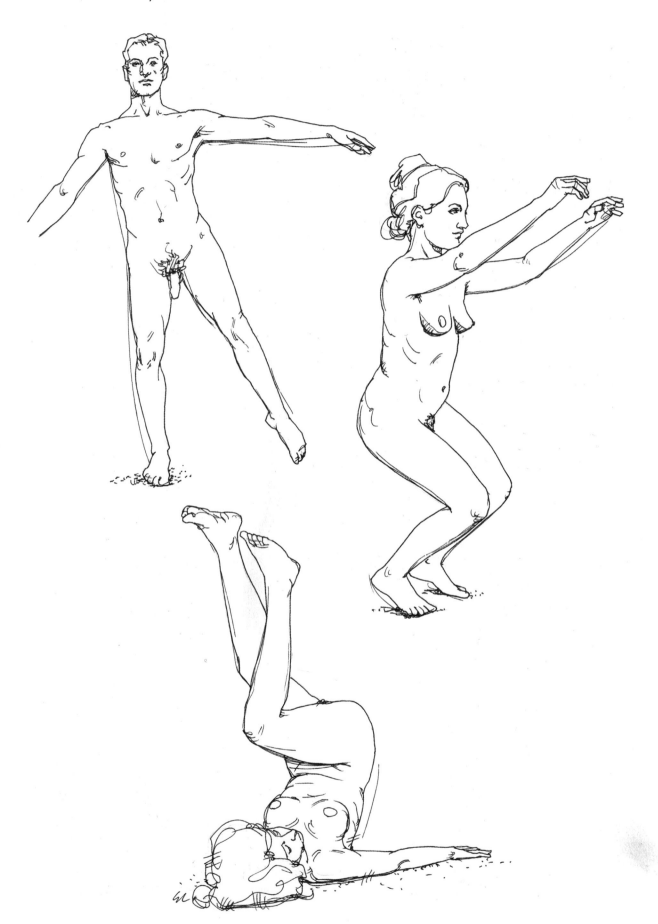

PLATES 44–46 (PAGES 69–71): CAPTURING A MOVING SEQUENCE

The drawing of a moving figure is effective and meaningful if the artist succeeds in grasping the exact moment and pose in which the body effectively appears to be in a state of precarious balance, but does not give the impression of the figure being fixed or frozen in this position, so to speak. The tendency of the action, of the direction in which the body, or part of it, is being pushed or pulled by the movement must transpire from the drawing. All actions are characterised by a moment that seems to sum up the entire movement and a viewpoint that best lends itself to express it, as can clearly be seen in photographs of athletes in action. In running, for example, the moment of greatest effect and dynamic suggestion corresponds to the point of the forward-most imbalance of the body, especially if seen from the side. In walking, on the other hand, it is easier to see the continuous alternation of the tendency to fall forward and regain balance, which permits the body to move (plate 46).

The movement illustrated in plate 45 quite clearly expresses the need to observe the moving model carefully and intelligently, making him repeat the action slowly over and over again. Out of this sequence of four figures, only the first contains a strong dynamic charge able to suggest that the body was 'surprised' during a movement, while the others appear almost static, especially if viewed individually.

It is therefore possible to identify two different ways of proceeding when drawing the moving figure (human or animal):

1. Observing the unfolding of an action throughout its various phases and seeking to record it as you watch. This has a number of useful educational benefits. For example, you are forced to record the essential aspect of a phase using just a small number of marks, before the model goes on to the next phase; you can only continue with the drawing for as long as the figure is completely in sight; it requires intense attention to impress the dynamic variations in the volumes of the body on the mind; it provides training in rapid hand-eye coordination, etc.

2. Observing the figure and his or her action closely, by drawing a mental picture so as to train your visual memory and impress all the relevant and significant data concerning the form of the body on your visual memory, then being able, once the action has concluded, to draw it effectively, using the information stored in your mind.

Plate 44 suggests a graphic trick that can help depict moving body parts. Photographic and film experience has taught us that the portion of the human body that always appears well-defined, clear cut and almost immobile is the trunk, while the limbs (especially the hands and feet) appear almost indistinct because they move so much more quickly. Although less intense, the same effect can be observed in the model who is trying to maintain an unstable position: the limbs, which move through space in order to seek the necessary balance, are subject to vibrations as a result of the protracted muscle contractions, working against the force of gravity, or due to the speed of the action.

Plate 44: Capturing a Moving Sequence

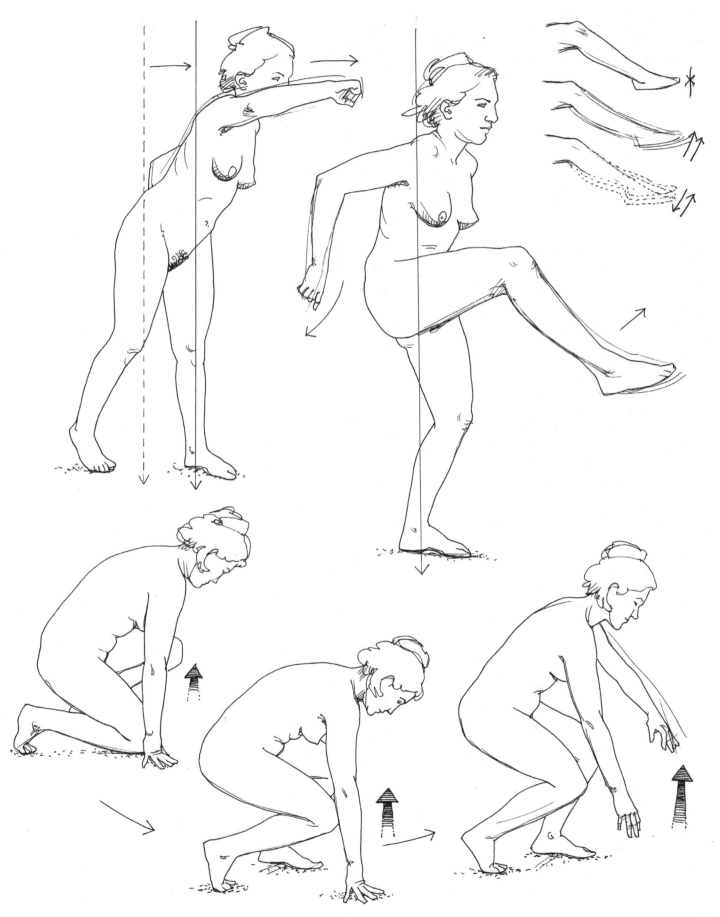

Plate 45: Capturing a Moving Sequence

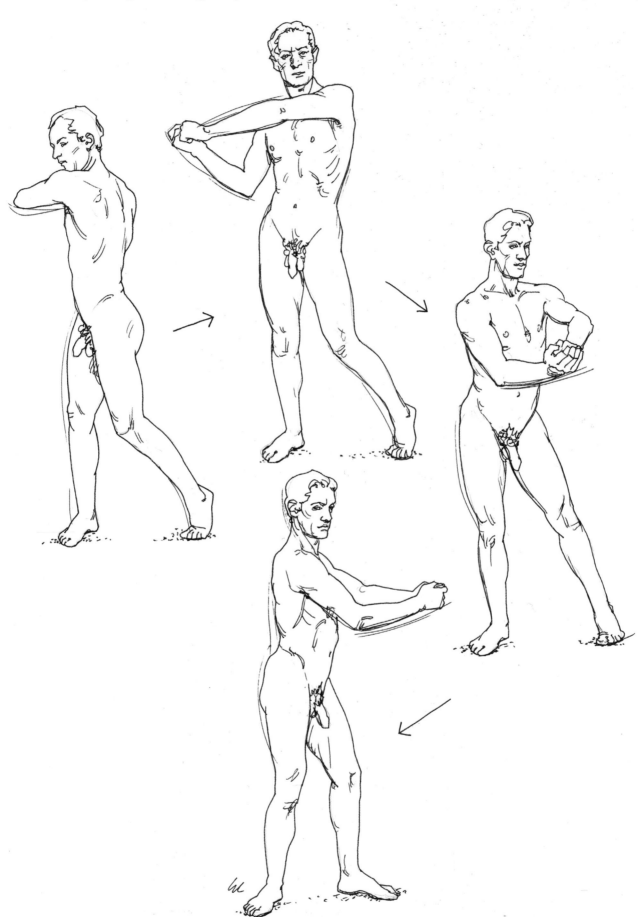

Plate 46: Capturing a Moving Sequence

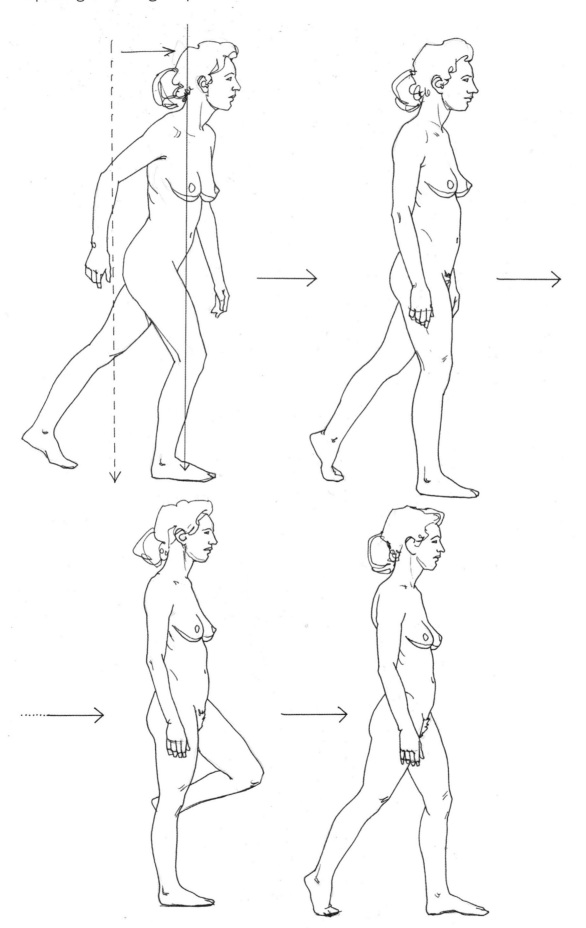

EXERCISES TO ENERGISE AND INSPIRE

'The most daunting tasks are the least to be feared.'

During my art classes, I suggest certain exercises (which can be done using any drawing or painting technique) that I believe are useful for stimulating and strengthening observational skills in my students. Better yet, they also fuel curiosity, that healthy desire to investigate and that subtle perceptive awareness that take one beyond what is real, discovering unknown or simply obscure sides to things and providing a reason for what is seen. These exercises sometimes create a little unease among my students because they seem to be contradictory or lacking in connections. Some processes appear to stimulate rationality, reflection and analysis, while others incite the emotions, spontaneity and the use of instinct.

Rather than suggesting and implementing a drawing method for immediate practical application, to be followed mechanically (something which is sadly still sought after and demanded by many beginners or those lacking in motivation), these experimental exercises seem to create some confusion and do away with things that might have been taken for granted. It is precisely this aspect that is so useful in pedagogical, almost maieutical terms. [The maieutic teaching method is based on the idea that we all know the truth deep inside ourselves but that it has to be brought to the forefront of our minds by sensibly considering the answers to the right questions.] This is the process that should enable each student to find the internal motivation to draw and the best ways to express him or herself.

These exercises focus on life drawing, working directly with a model (nude or clothed, male or female), because in many circumstances it is essential to check the finished drawing against the natural body. However, sometimes you can work from photographs (projected as slides if possible) or a mannequin constructed with sufficient anatomical and proportional realism.

PLATE 47 (OPPOSITE): DRAWING FROM A DIFFERENT VIEWPOINT

Illustrations A and B: Position the model in any pose and try to draw him or her as if seen from a different angle. For example, if the model is seen from the front, draw him or her as you know (or imagine) he or she must appear from the side, right or left, or from the back. At the end of the session, check the accuracy of your drawing by comparing it to the model in the same pose, but now from the corresponding viewpoint. After a critical examination, make the inevitable necessary corrections.

Illustration C: Try a similar exercise by drawing the mirror image of the model. Some art schools are fitted with large mirrors arranged around the room in various positions in order to achieve these effects and facilitate study. However, it is only advisable to make use of these for the purposes of closer comparison or more detailed checks. You should do the actual drawing by simply deducing the form from your chosen viewpoint of the life model, creating the imagined image without seeing it directly from life.

This exercise helps students to reflect on the close attention that must be paid when observing the model during life-drawing sessions from multiple viewpoints, enabling them to grasp a full understanding of the three-dimensionality and complexity of the anatomy. By 'consulting' the forms of the model (and not merely reproducing them passively), you should be able to combine the notions of anatomy, morphology and analysis of the balance of the pose, attributing shapes to forms, etc. so as to construct the aspects of the body that are not directly visible.

Plate 47: Drawing from a Different Viewpoint

A

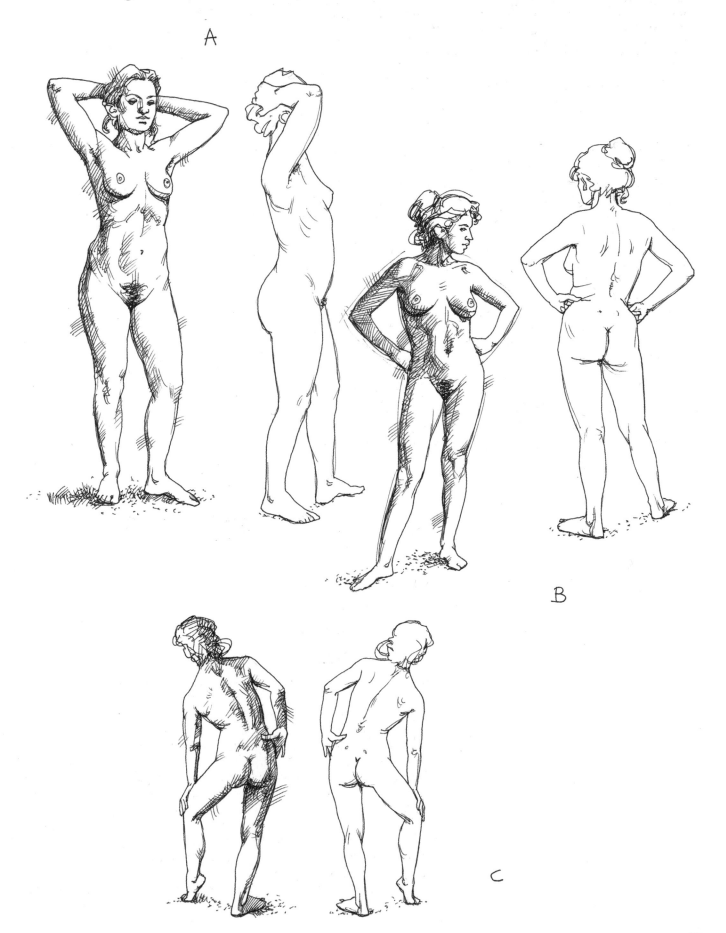

B

C

PLATE 48 (OPPOSITE):
DRAWING WITH LINES AND ANGLES

This exercise involves drawing all the forms and profiles of the human body without using curved lines, but instead using only short straight lines placed at the appropriate angles. The figure obviously assumes a rather unnatural 'angular' appearance, perhaps better suited to conveying the character of male profiles than those of the female body.

This exercise is useful for training students to identify and break down the volumes, tonal planes and masses that form the figure, giving solidity and clarity to the forms, especially the profiles, and recognising areas of continuity or contrast.

Plate 48: Drawing with Lines and Angles

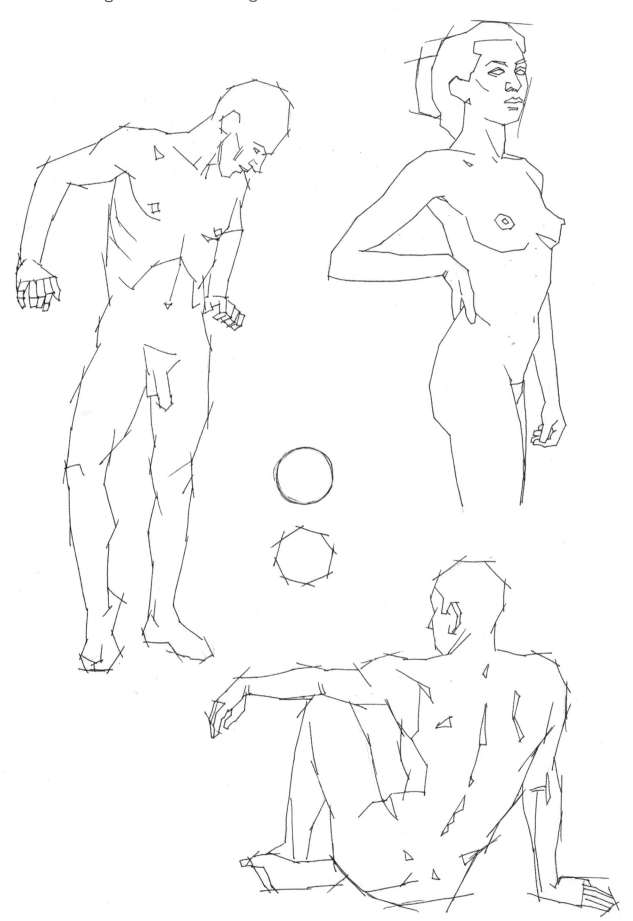

Plate 49: Studying the Details

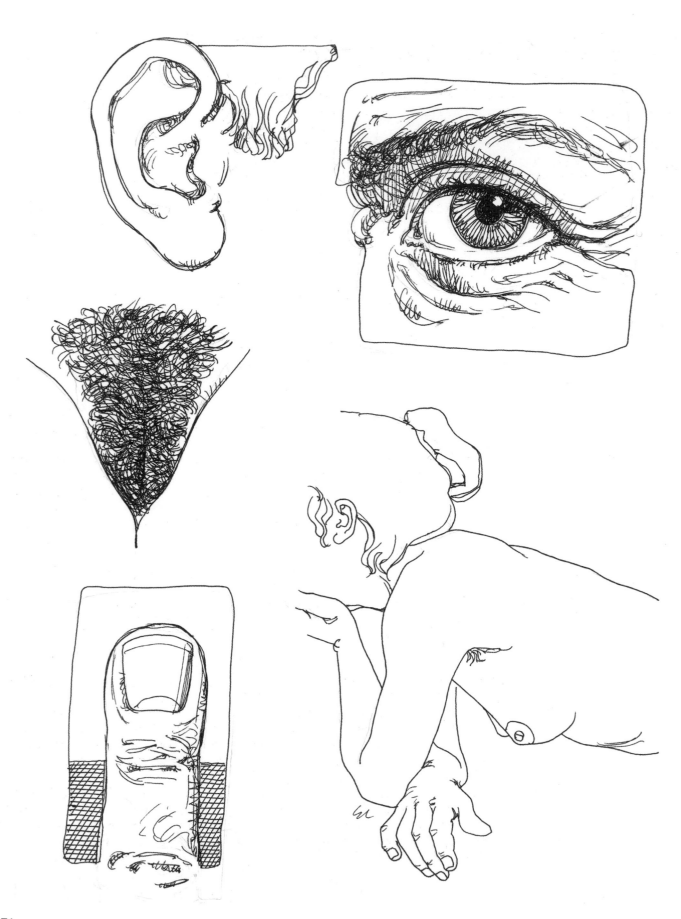

PLATE 49 (OPPOSITE): STUDYING THE DETAILS

By observing the model in extreme close-up, you achieve strong distortions in perspective and a substantial loss of the overall vision, but you also enter an unusual world of morphological details able to suggest special compositions or minute formal analyses, often almost abstract in appearance. A close-up view isolates and enlarges the detail, highlighting structures and formations that it is impossible to grasp from a normal distance. It invites analytical examination, which should also be applied when drawing the figure as a whole. This provides a healthy antidote to routine in terms of observation and interpretation.

The close-up view also involves some subtle emotional implications because it is effectively an intimate gaze, the violation of the other person's space; this needs to be taken into account when doing the exercise.

PLATE 50 (PAGE 78): WORKING WITH SIMPLIFIED TONES

The volume and weight of the body are expressed through the modulation of forms to suggest three dimensions. You can experiment by using just two tones, one light and one dark, each reserved for a specific tonal area: the light one to indicate the 'local' colour, that is to say the generic tone of the figure as a whole, and to indicate the protruding, illuminated areas of the volumes, and the dark one to indicate the shaded zones, the recesses and the receding sides of the volumes.

PLATE 51 (PAGE 79): EXPLORING LINE

Lines and tones are the fundamental expressive components of drawing. Every so often it is good practice to explore the different qualities of line and its countless possible mark-making and hatching combinations for achieving tonal effects.

PLATE 52 (PAGE 80): STUDYING LIGHT AND SHADE

Light and shade create the tonal modulation of the particularly complex forms of the human body. However, the geometric principles behind the formation and projection of shadows apply to any object and the rules that govern their main effects are actually quite intuitive. Despite this, it is also important to practise by drawing fundamental geometric shapes (cylinders, spheres, cubes, etc.) because the effects of light and shade on these solids are simple and well defined. After some preliminary exercises, plate 52 shows a more detailed and thorough study of the effects of lighting on the human body: a fairly concentrated and intense light is projected on to the model, showing surprising variations in the appearance of the same reliefs and depressions on the surface of the body: lighting from the front (A); side lighting (B); side lighting from above (C); lighting from above (D) and lighting from below (E).

Plate 50: Working with Simplified Tones

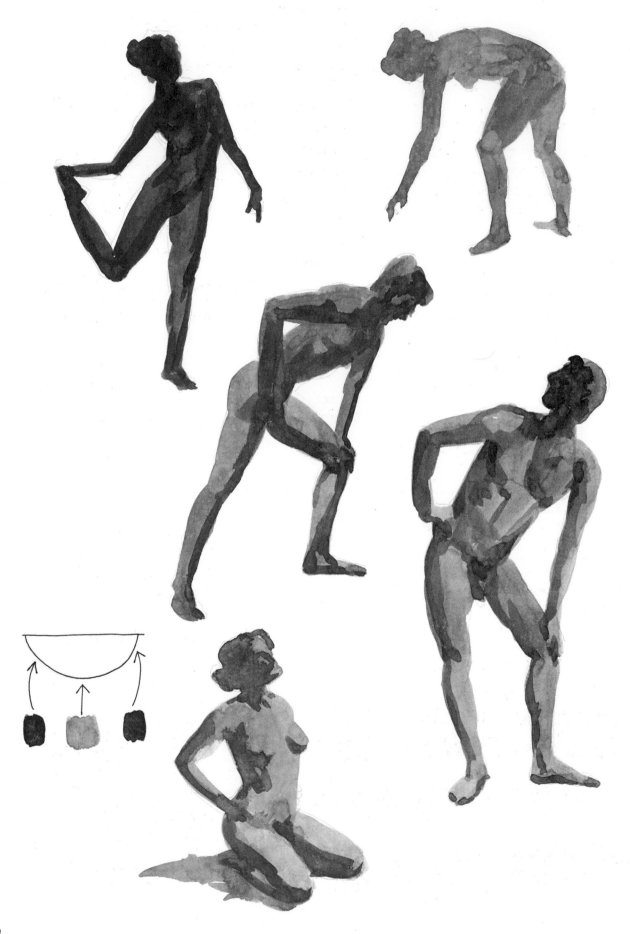

Plate 51: Exploring Line

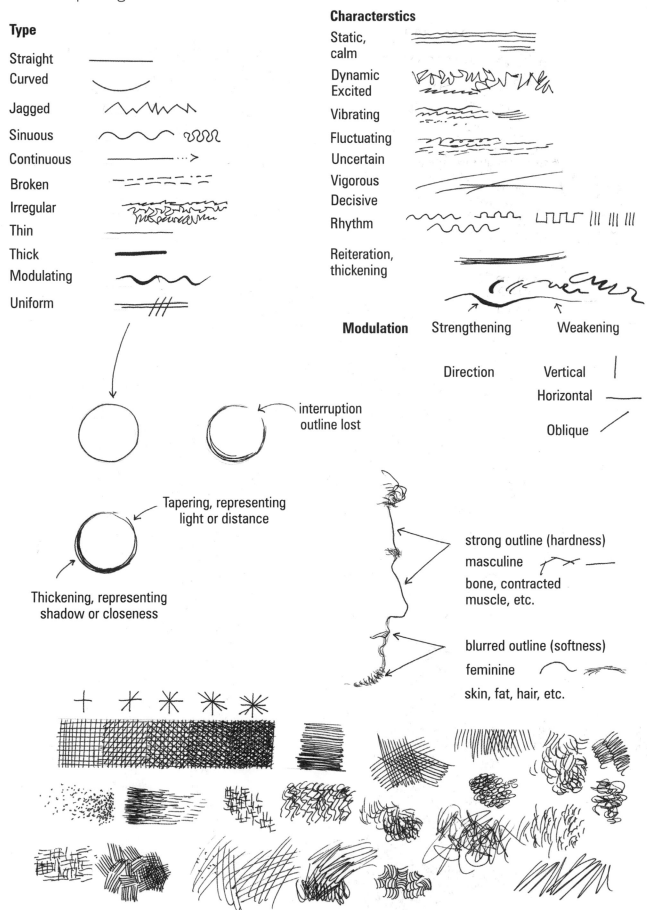

Type

Straight

Curved

Jagged

Sinuous

Continuous

Broken

Irregular

Thin

Thick

Modulating

Uniform

Characterstics

Static, calm

Dynamic Excited

Vibrating

Fluctuating

Uncertain

Vigorous Decisive

Rhythm

Reiteration, thickening

Modulation Strengthening Weakening

Direction Vertical

Horizontal

Oblique

interruption outline lost

Tapering, representing light or distance

Thickening, representing shadow or closeness

strong outline (hardness)

masculine

bone, contracted muscle, etc.

blurred outline (softness)

feminine

skin, fat, hair, etc.

Plate 52: Studying Light and Shade

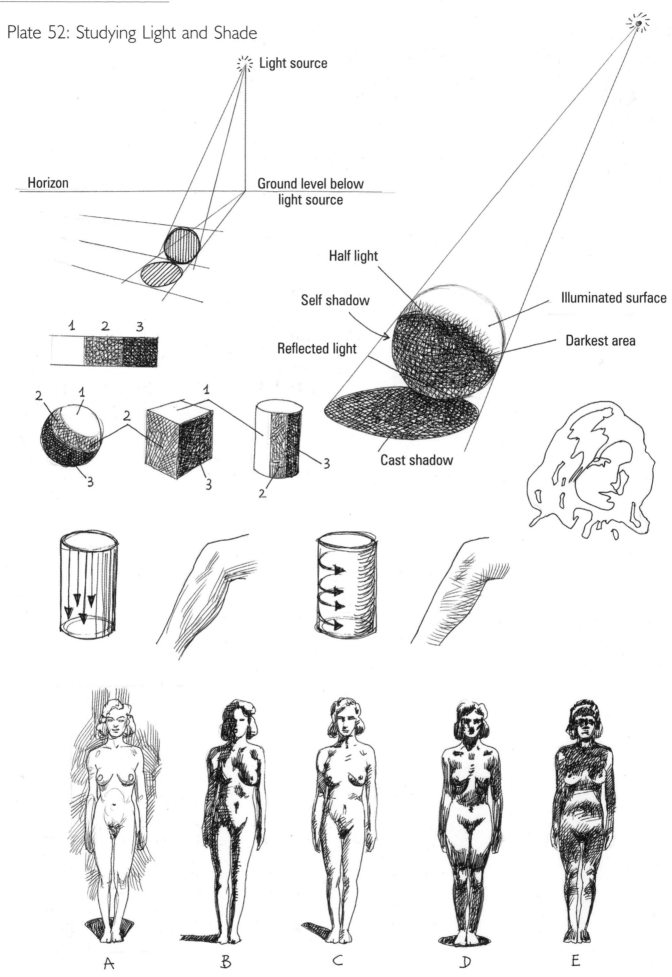

Light source

Horizon

Ground level below light source

Half light

Self shadow

Reflected light

Illuminated surface

Darkest area

Cast shadow

1 2 3

1 2 3 1 2 3 1 2 3

A B C D E

PLATE 53 (PAGE 82):
MOVING THE MODEL IN RELATION TO THE LIGHT

By turning the model slightly, you can expose a different quantity of the surface of his or her body to the direct light, discovering interesting effects created between the figure and the background and on the figure itself.

Two types of drawing can be used for this exercise: quick sketches, made in a few minutes and intended to capture the overall effect of the tonal contrasts, or sustained drawings, made with greater care and more slowly in order to assess the more complex relationships and the subtlest passages between the illuminated areas of the body, the areas in shade and the areas that receive some degree of reflected light (see also plates 52 and 56).

PLATE 54 (PAGE 83): DEPICTING SHADOWS ONLY

Depicting only the areas of shadow is a useful exercise for focusing the artist's attention on the model's volumetric forms, rather than concentrating simply on the profiles. Areas of shadow should be assessed as forms in themselves, reproduced without modulations. They should make the figure emerge without the aid of other graphic means such as lines or intermediate tones. The drawing should feature only black in the shaded areas and only white in the illuminated areas.

PLATE 55 (PAGE 84): DRAWING OUTLINES ONLY

Linear drawing (only drawing the outlines) is done by closely observing the profiles of the model's body (not just the outermost one, the external outlines, but also those which describe or suggest the most significant parts of the body). You need to run your eye over them slowly, marking out their passage on the sheet of paper. Linear figure drawing entails the essential 'purification' of forms, featuring only the proportional and spatial relationships and the graphic interweaving of the forms. However, this alone is sufficient to create a suggestion of volume without the use of tonal modulation, simply marking out shadows, reliefs or recesses on the surface of the body if necessary.

PLATE 56 (PAGE 85): TONAL DRAWING

This exercise is similar to that proposed in plate 53 and naturally counterbalances the purely linear exercise of the previous plate. It involves depicting the model through the use of tonal gradations from light to shade, assessing the extent and intensity of the tones in the dark areas, the projected shadows, the reflected light, etc. and thereby simulating the three-dimensional relief of the body forms. When doing this exercise it is advisable to use only a small range of tones, perhaps three or four for example (white, light grey, dark grey, black), with which it is easy to achieve a good wealth of intermediate tones without blending them in an excessively affected fashion.

Plate 53: Moving the Model in Relation to the Light

Plate 54: Depicting Shadows Only

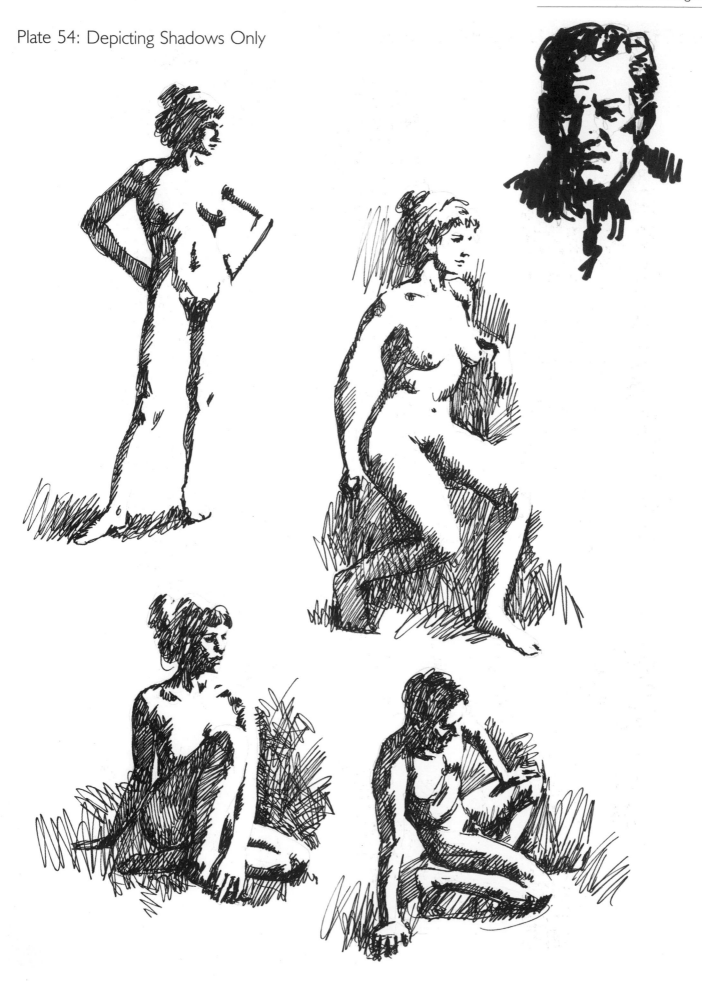

Plate 55: Drawing Outlines Only

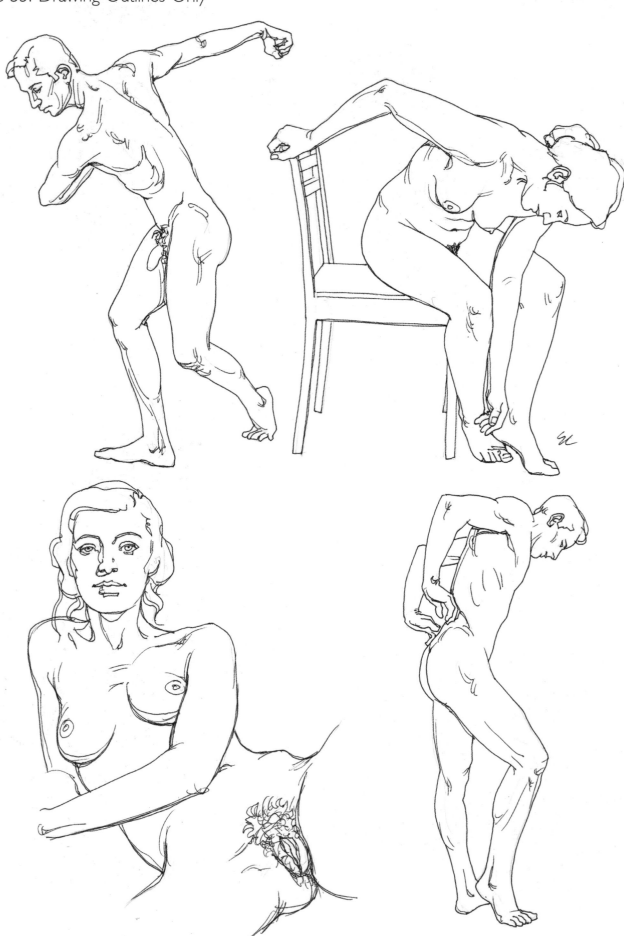

Plate 56: Tonal Drawing

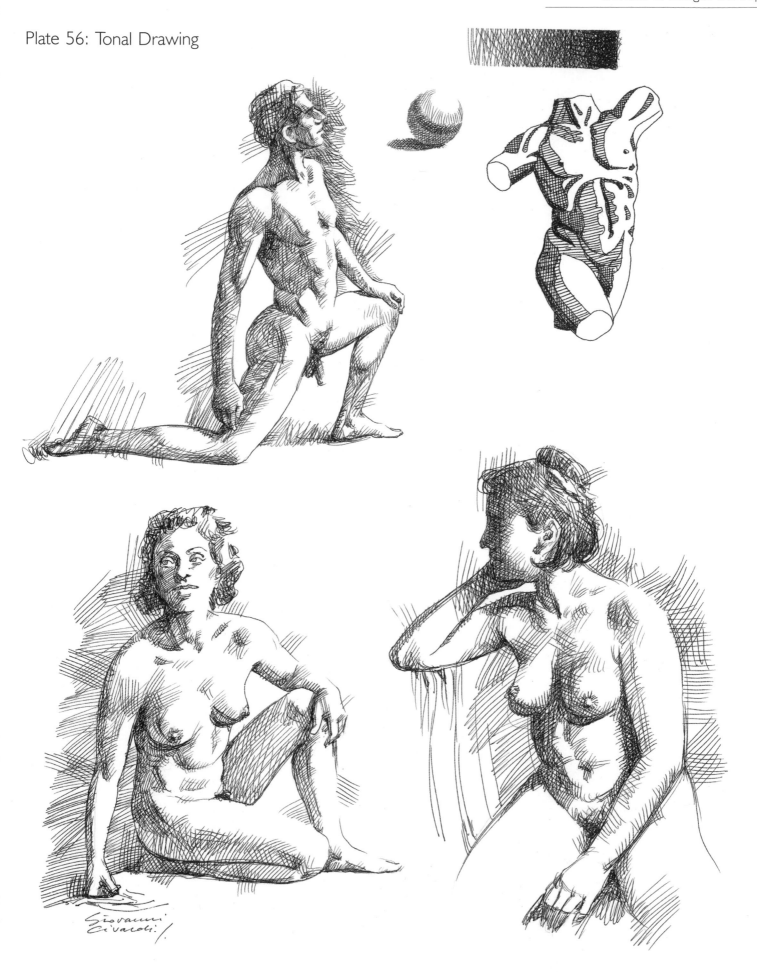

PLATES 57 AND 58 (PAGES 87–88): GESTURE DRAWING

Gesture drawing involves sketching very quickly: each drawing must be concentrated within the space of a minute or just over, and you need to do lots of them, focusing on the 'character' of the gesture and the pose. While your eye remains permanently fixed on the model, your pencil or pen should run freely over the sheet of paper without ever breaking contact, investigating the figure in its overall unity, almost brushing aside the surface of the body and simply grasping the sensations aroused by the model's action and his or her dynamic tension, rather than the appearance. Obviously, this kind of quick drawing is nothing more than a sketch or 'scrawl' from an aesthetic point of view, but this exercise is extremely useful for coordinating vision, emotion and graphic action. Keeping these principles in place, the execution times can be extended up to around five minutes in order to create slightly more elaborate and significant drawings.

PLATE 59 (PAGE 89): DRAWING HANDS AND FEET

Every so often it is advisable to supplement your study of the human figure as a whole with a closer examination of some of its parts. The hands and feet, for example, are very significant for this type of analytical study: they have anatomically complex forms and structures and can make numerous different movements, all packed with meaning. As usual, the exercise I propose involves doing a rough drawing of the whole figure, then moving closer to the model in order to enlarge the details of the hands and feet as they are seen in the pose. Sometimes I suggest doing it the other way round, starting with the detail and moving on to the general view: beginning the drawing with a hand or a foot in an interesting position and 'connecting them' consistently to the whole figure.

However, it is important to train yourself to maintain an overall vision of the human body, even if the current intention requires the analysis of just a very small part. Therefore, to this end it is preferable to work from a life model or, in the absence of one, you can study your own hands and feet reflected in a mirror.

Plate 57: Gesture Drawing

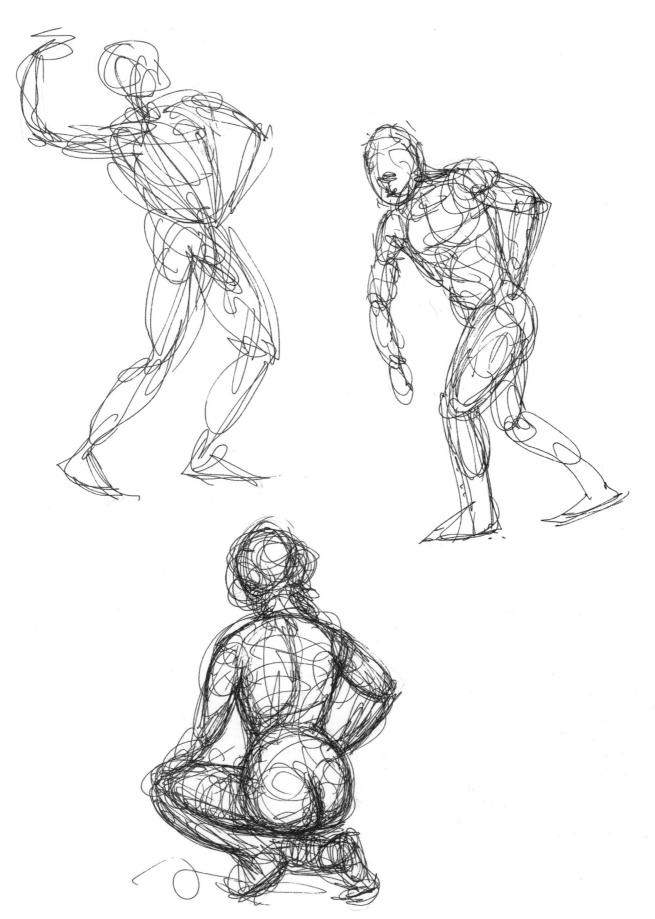

Plate 58: Gesture Drawing

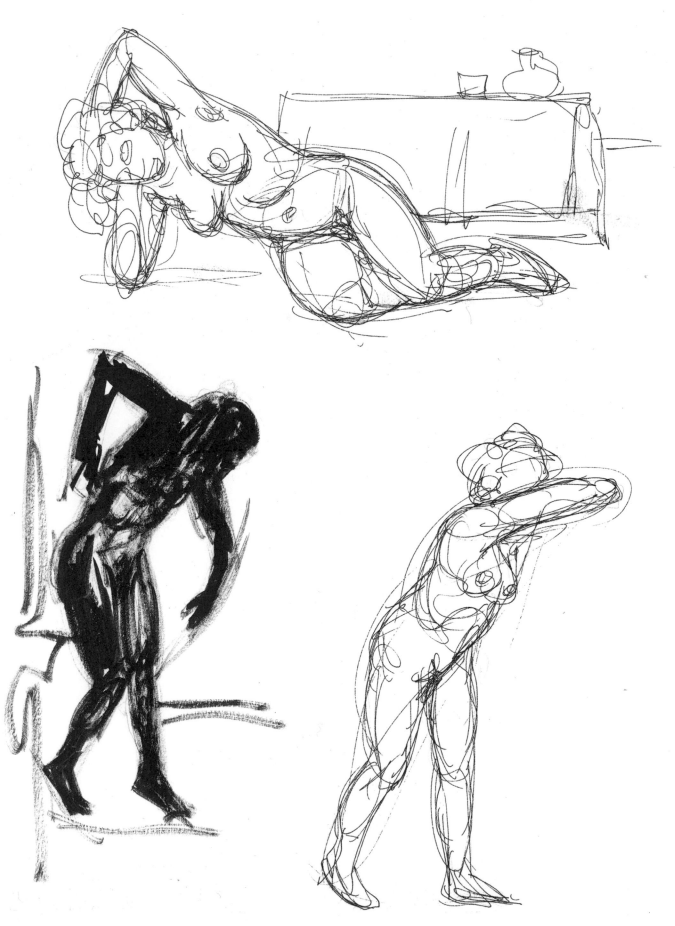

Plate 59: Drawing Hands and Feet

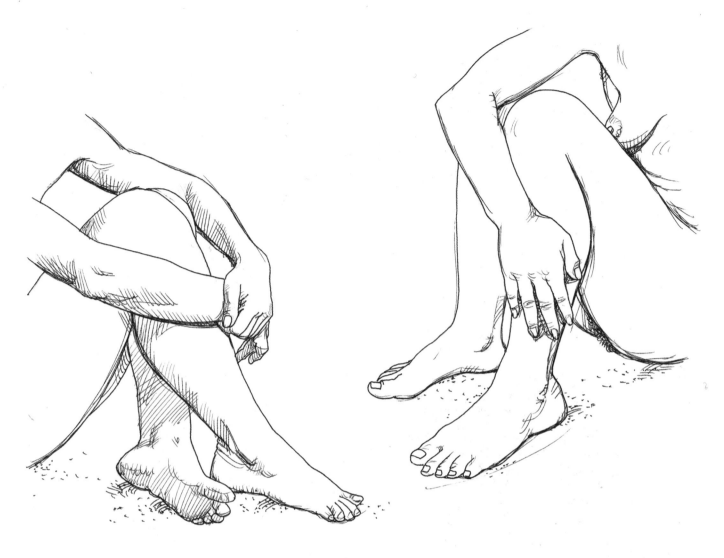

PLATE 60 (OPPOSITE): DESCRIBING DIFFERENT SURFACES

In this exercise you need to observe the model's body in extreme close-up in order to portray not so much the morphological characteristics, as the apparent quality and structure of the different surfaces of the skin, nails, hair and so on. By doing so, you will uncover certain contrasts (hard/soft, smooth/rough, tense/relaxed, etc.) and some specific characteristics (hair, mucous membranes, folds, nails, wrinkles, etc.), finding the most appropriate way to differentiate between them in drawing.

PLATE 61 (PAGE 92): ABSTRACTING THE FIGURE

Considering the model as a source of information and as an initial physical reference point, we can gradually simplify the forms of the body until all references to the figure have been eliminated, creating a purely abstract composition. You can use lines of contrast and lines of continuity, breaking up the figure into elementary geometric shapes, etc. to find starting points from which to proceed in a freer, more creative style. Particular attention should be paid to the phase in which the figure is at the extreme limit of recognisability, in which a semblance of the pose and human form can still be perceived, because in terms of objective observation, this is the critical point and the limit of the selective and simplification process. This stage indicates which elements can be overlooked and which, on the other hand, it is absolutely essential to recognise and keep in the drawing.

Plate 60: Describing Different Surfaces

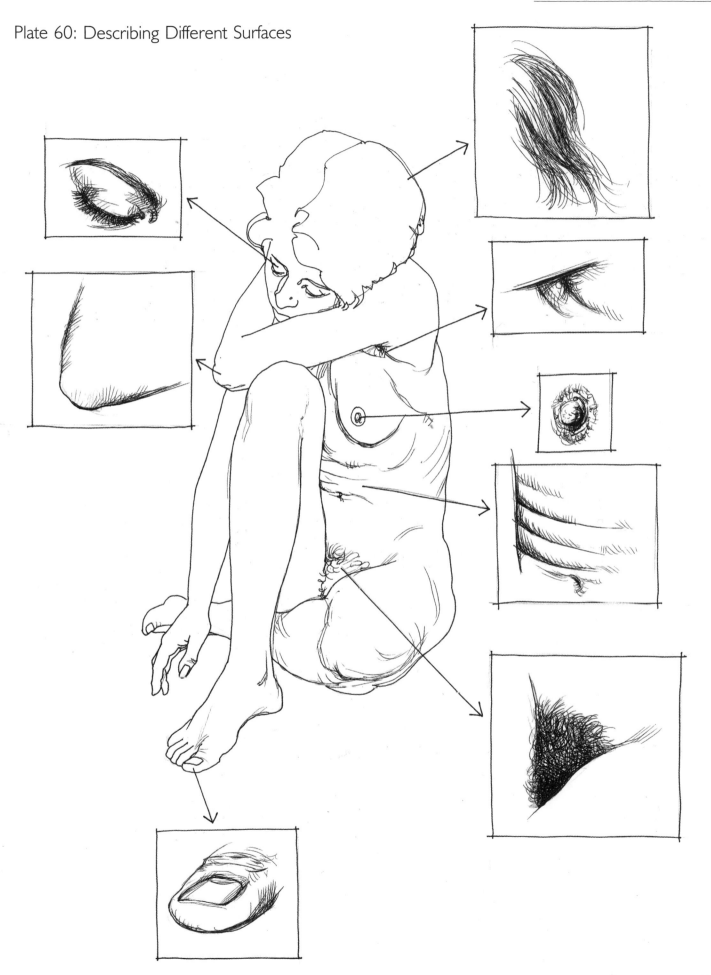

Plate 61: Abstracting the Figure

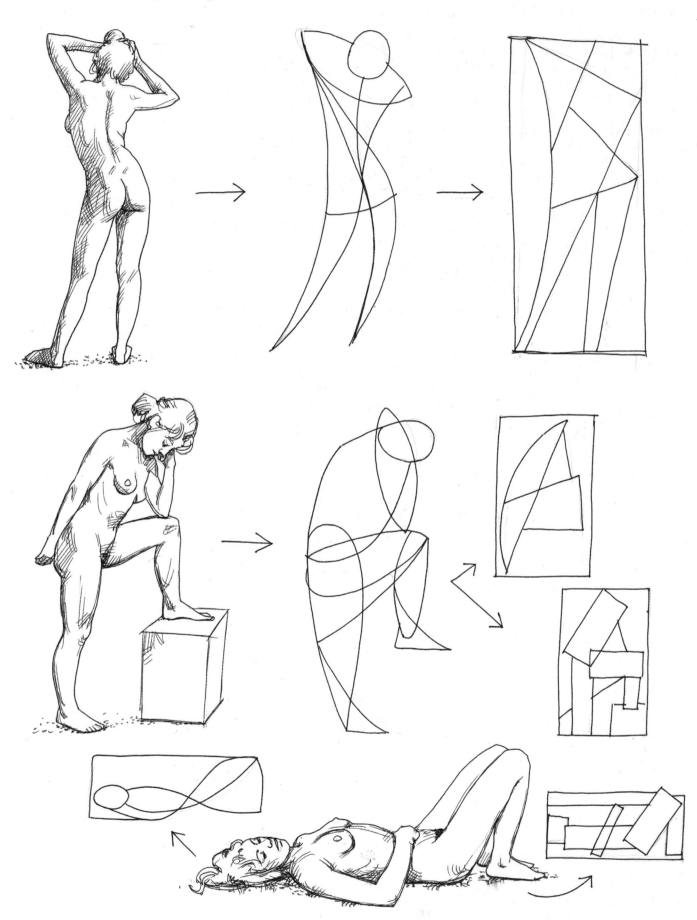

PLATES 62–64 (PAGES 94–96): DRAWING DRAPERY AND CLOTHING

Exercises in the study of drapery offer two opportunities. The first concerns the analysis of the folds formed in the various fabric types and how they are arranged on the human body, allowing the viewer to note where the fabric adheres to the body in points of tension and the thickening or curving of the fabric in the points of flexion, with very different characteristics depending on whether the fabric is light and thin (linen, silk, etc.) or thick and heavy (wool, cotton, velvet, etc.).

The second opportunity more specifically concerns the way in which the fabric or clothing adapts to the body, following its movement and morphology. The drapery covers the body without hiding, or only partly concealing, its anatomical structure, especially in the joint areas. In these cases it is therefore easy to depict this structure in the drawing, but even in the zones with larger folds or draped fabric, it is necessary to perceive and convey the support provided by the body beneath. Plates 63 and 64 propose some exercises for exploring the relationships between the nude body and the clothed body or the body covered by light drapery.

In the past, painters began by studying the nude figure and then draped it; these days, on the other hand, it can be interesting and stimulating (as an exercise in observation) to draw the clothed figure first, seeking to perceive where the fabric follows the body form and assessing the points at which it influences the fabrics, then drawing the nude body of the model in the same position and making the necessary comparisons and considerations, checking the accuracy of the original observations as regards the relationships between the body and the fabric.

Plate 62: Drawing Drapery and Clothing

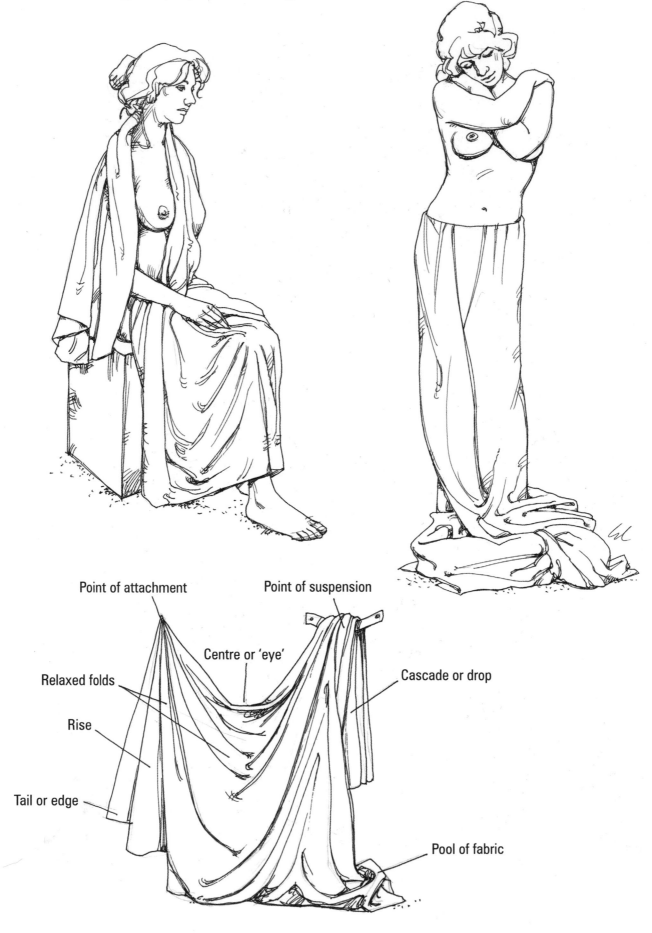

Point of attachment

Point of suspension

Centre or 'eye'

Relaxed folds

Cascade or drop

Rise

Tail or edge

Pool of fabric

Plate 63: Drawing Drapery and Clothing

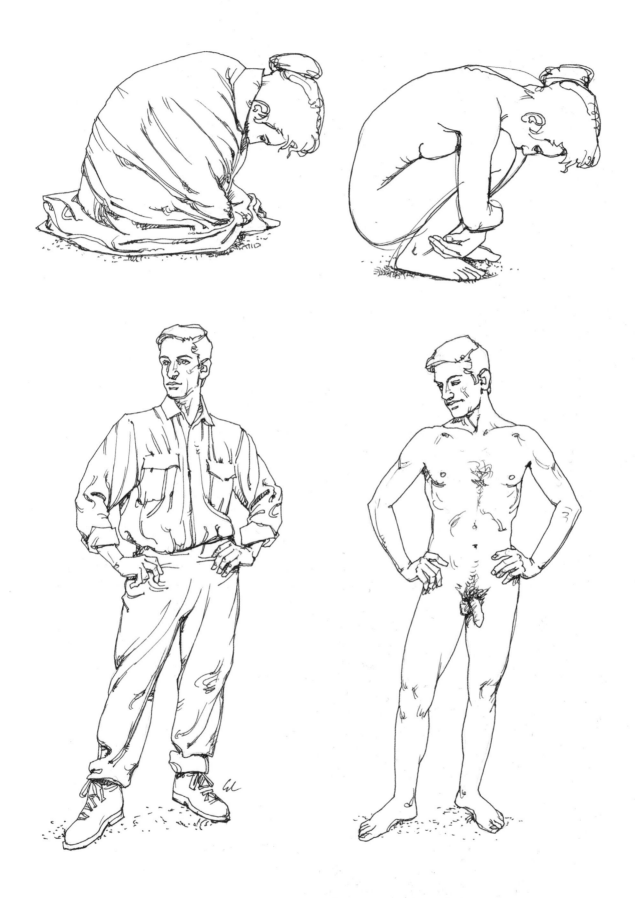

Plate 64: Drawing Drapery and Clothing

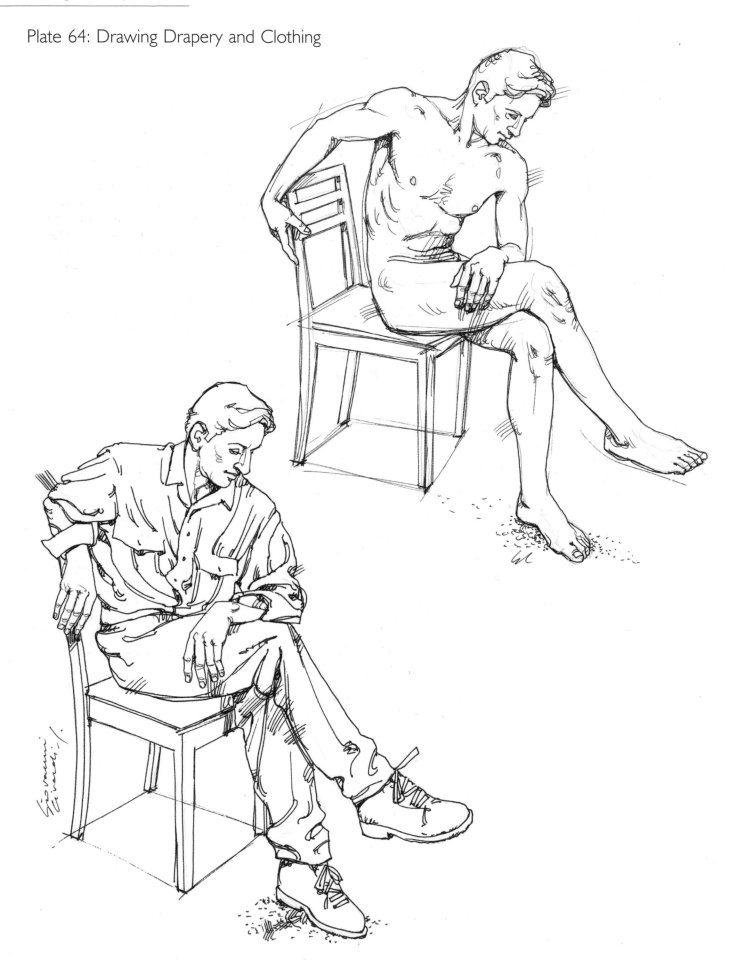

PLATE 65 (PAGE 98): INCLUDING THE SETTING

In drawings of the nude, there is always a tendency to consider the body as being isolated in its pose. A useful exercise for broadening this academic horizon consists of drawing the figure in the setting in which it is posed, creating an interesting composition and a more evocative atmosphere. Making reference to elements of the setting also contributes towards a better understanding of the body proportions, the orientation of the limbs and the state of equilibrium, effectively resolving the most daring foreshortened features or creating unusual effects of light and shade.

Usually, the setting used for the nude is an interior – part of a studio or a home, for example – but if the weather conditions and privacy requirements permit, open-air nude studies, in the natural environment, can be particularly interesting and useful.

PLATE 66 (PAGE 99): STUDYING THE HEAD

Like the hands (see plate 59) the human head has a very complex structure. Making a concentrated study of the head can be done for two purposes. The first purpose is to draw the head simply in terms of its form, volume, and the proportional relationship between the individual component parts, etc. This naturally flows into the second purpose, which involves the faithful portrayal of the model, focusing not only on his or her physical features (the portrait can be limited to just the head, or extended to the whole figure), but also to his or her character and expression.

Naturally, any model is suitable for this type of study: men, women, young people, old people, people of different races, etc.

Plate 65: Including the Setting

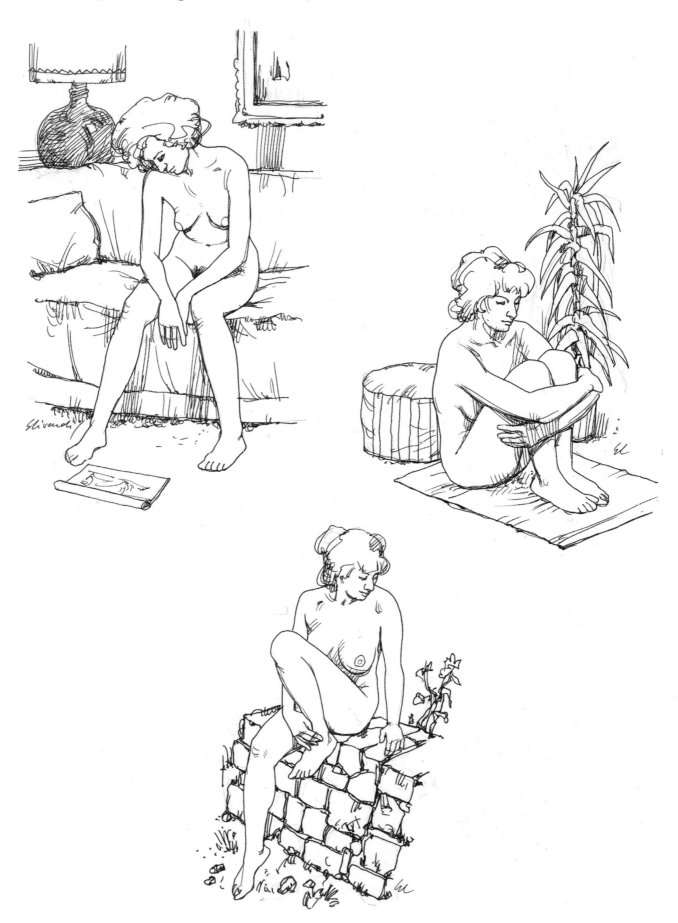

Plate 66: Studying the Head

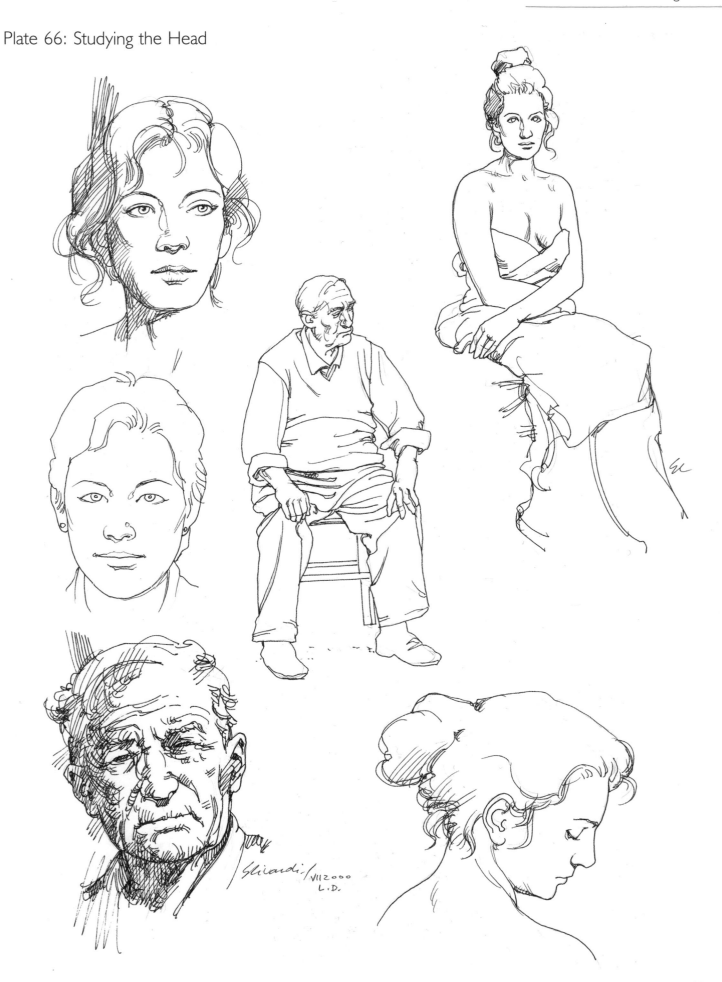

PLATE 67 (OPPOSITE):
CONSIDERING DIFFERENT ARTISTIC APPROACHES

The study of the human figure is not just an anatomical exercise to its own ends, but also the best way of expressing one's sensations or intentions through the depiction of the most complex subject in nature – the human body (or, to express it more precisely, the body of a human being).

The exercise on abstracting the figure shown in plate 61 invites you to negate and surpass the body as an effective reality. This exercise should lead you to reflect on the different methods and styles (both personal, and from different periods) in which the human nude has been interpreted in various artistic cultures, and on the degree of anatomical faithfulness achieved or accepted.

Countless different examples are available to us: just flick through a book on the history of art, either from the Western world or other cultures, and choose some nude images. Then place your model in the same position, in the same pose, with similar lighting and make three observations:

1. Study the appearance of the model in a clinical manner, concentrating on his or her anatomical/morphological structure.
2. Now draw the model, trying to 'enter into' the style of the artist in question and trying to surmise or perceive the reasoning behind his or her interpretation and use of simplification.
3. Lastly, draw the model in your own style of interpretation.

The sketches in plate 67 show the following subjects:

1. *The Pugilist*, bronze, h. 128cm (50¼in), Roman sculpture from the 2nd century B.C.
2. Painting from the tomb of Nakht, in Thebes, New Kingdom (18th–20th dynasty, 1567–1088 B.C.)
3. *Venus*, Lucas Cranach, c. 1530.
4. *Dying Slave*, Michelangelo Buonarroti, c. 1530.
5. *Venus of Urbino*, Titian, 1538.
6. *Blue Nude*, Henri Matisse, 1907.
7. *Naked Girl Perched on a Chair*, Lucian Freud, 1994.
8. *Large Nude*, Georges Braque, 1908.
9. *The Crouching Woman*, Auguste Rodin, 1882.
10. *Friends*, Egon Schiele, 1913.

Plate 67: Considering Different Artistic Approaches

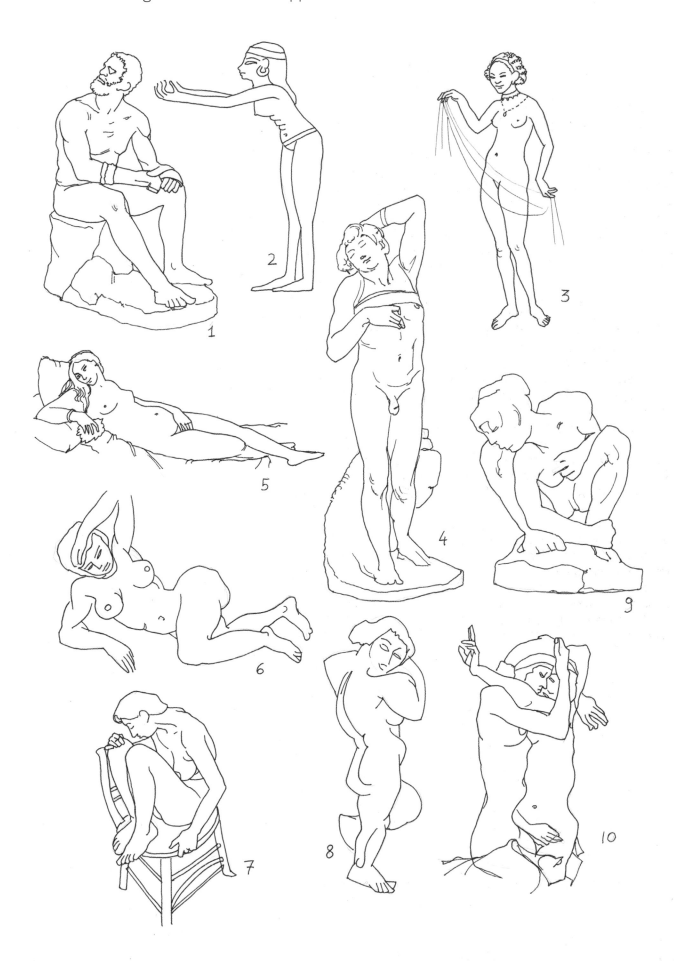

PLATE 68 (OPPOSITE):
CHROMATIC AND TONAL MODELLING

Using drawing tools you can create the illusion of volume with monochromatic tonal effects ranging from white in the illuminated areas to black in the most deeply shaded areas, via various shades of grey. Plate 60 looked at creating the surface textures of the body with line. This illustration looks at reproducing the colour of the skin, not so much in relation to the chromatic blends needed to simulate it in painting, but rather the way in which the skin colour looks different on the different parts of the body, represented in monochrome, in a series of greys (1 and 2), each of which corresponds to the tonal intensity of the colour observed in the model. For example, in the body and hair (and in proximity to the roots), on the lips, on the back of the forearm, on the ear, on folds of skin or skin pulled taut over bones, on nails, etc.

This exercise can be supplemented by further observations: by assessing the colour characteristics of individuals from different races; assessing the colour changes observed on the body of the model or on some body parts (typically the lower limbs) in a seated pose; using the drawing medium to follow the extension of the form (A) or to cross the form, scanning the tonal planes (B); lastly, by varying the chromatic warmth towards the hot range (tending towards red) or the cold range (tending towards blue).

Plate 68: Chromatic and Tonal Modelling

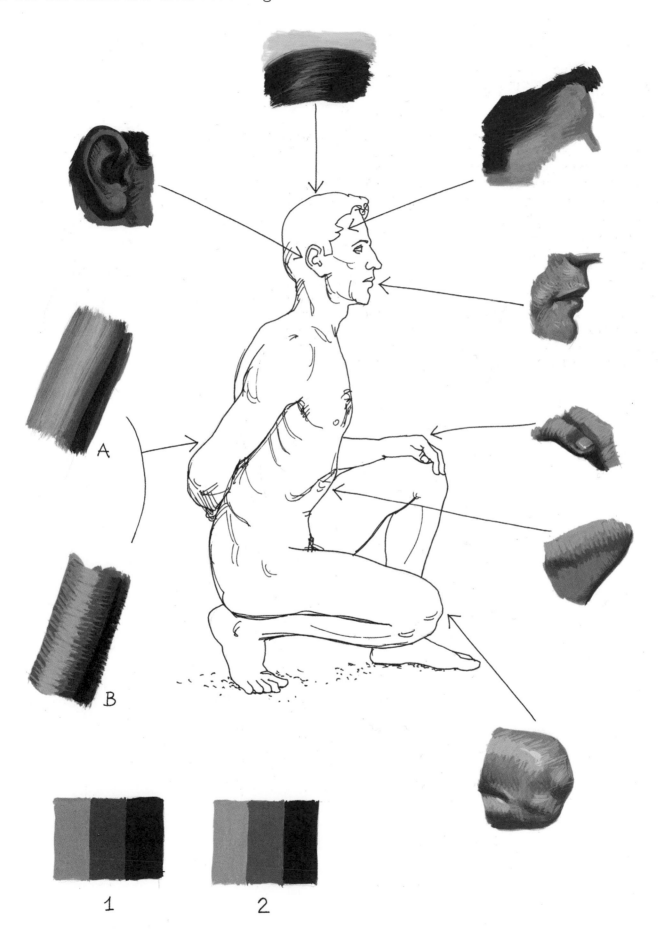

1 2

WORKING PROCESSES

'Ars est celare artem.'
[True art is to conceal art.]

Life drawing, as the detailed study of the human figure, can be done by following various procedures inspired by different methodological principles, all of which are valid and worthy of trying, but each of which has specific expressive and teaching purposes. I therefore felt it would be useful to provide at least a summary of the two extreme, opposing principles for the observation of reality in the following illustrations. The first is inspired by an analytical, rational and structural vision, the second is inspired by a perceptive and emotional vision. Both are obviously related and mutually complement one another in graduations correlated to the awareness and attitude of each artist, contributing to the creation of his or her specific style of · vision and interpretation of physical reality. The final plate, on page 109, sums up some of the most interesting and stimulating methods of depiction applied to drawing the human body.

PLATE 69 (OPPOSITE): STEP-BY-STEP ANALYTICAL APPROACH

The characteristics of this procedure can be better described by the use of various adjectives: analytical, linear, rational, controlled, logical, sequential, reductionist, etc.
Observing the model, in any pose:
1. Determine the maximum height, maximum width and centre point of the figure, and make other relative measurements; choose the appropriate format (see also plates 1 and 33).
2. Assess the geometric shape of the figure as a whole (2a) and of the individual body parts (2b) (see also plates 3, 20 and 21).
3. Assess proportions and dimensions by means of comparisons and vertical and horizontal alignments (see also plates 1, 17 and 27).
4. Indicate the skeletal structure and other elements of anatomical construction (see also plates 8, 9, 10 and 11).
5. Examine the profiles (5a) and the volumes (5b) indicated by the tonal masses (see also plates 50 and 55).
6. Develop the fundamental tones (see also plate 56).
7. Introduce additional intermediate tones and some details.

The 'observation' and 'comprehension' phases have now concluded and the 'interpretation' phase is about to begin. This phase can follow three different lines: idealisation (adaptation of the image of the body to a precise aesthetic ideal), objectivity (very faithful reproduction of the model's natural body), and interpretation in a strict sense (alteration of the forms, omissions or stylistic and expressive accentuations).

Plate 69: Step-by-Step Analytical Approach

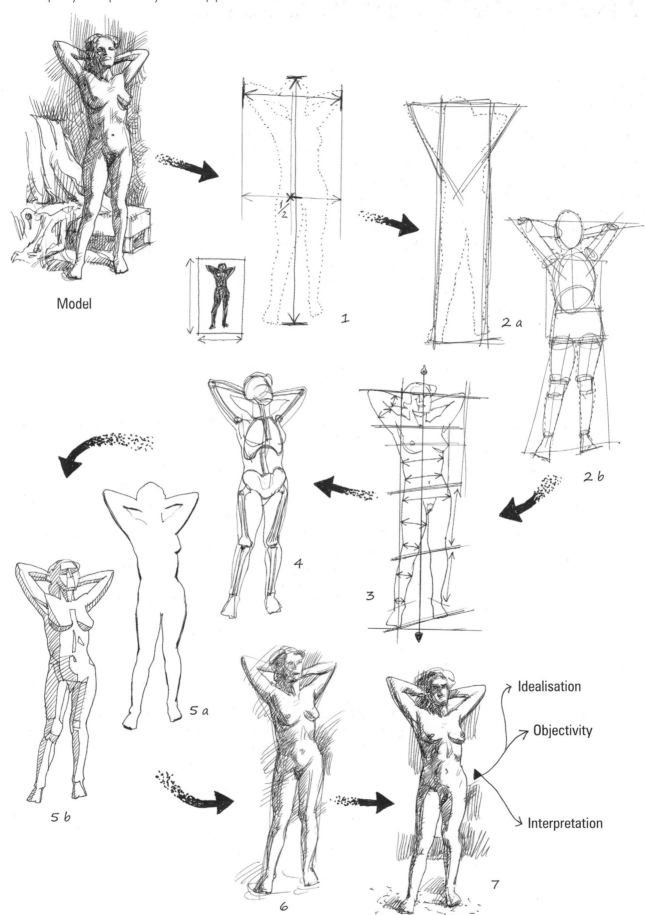

Model

1

2 a

2 b

3

4

5 a

5 b

6

7

Idealisation

Objectivity

Interpretation

PLATE 70 (OPPOSITE):
STEP-BY-STEP PERCEPTIVE APPROACH

The characteristics of this procedure can be better described by the use of the following adjectives: synthetic, global, intuitive, free, emotional, simultaneous, holistic, etc.

Observing the model, in any pose:
1. Observe the overall formal characteristics – horizontal, vertical, curled, angled, etc. (see also plates 3, 5, 38, 39 and 40).
2. Observe the relative characteristics of the main forms – acute, obtuse, angular, concave, convex, long, short, smooth, rough, etc. (see also plates 20, 48 and 60).
3. Recognise the expression, the character, the formal tensions – closed, open, tense, relaxed, etc. (See also plates 4, 6 and 7).
4. Make a gesture drawing of the overall form (see also plates 57 and 58).
5. Observe the fundamental structural outline – direction of the axes, orientation of the pelvis and spine, etc. (see also plates 20 and 22).
6. Consider the negative spaces as in 6a (see also plate 2). Use formal and expressive means to unify the body parts as in 6b– flow lines, rhythm, etc.
7. Introduce details and significant values – light, shade, reflections, etc. (see also plates 53, 56 and 59).

Unlike the procedure summed up in plate 69, which involves some subsequent phases of observation and the further development of the drawing, the procedure described here should have a more global connotation, involving almost simultaneous visual perception and drawing with no clearly distinct phases. In fact, the various phases should be condensed into an overall 'Gestalt' type impression.

Plate 70: Step-by-Step Perceptive Approach

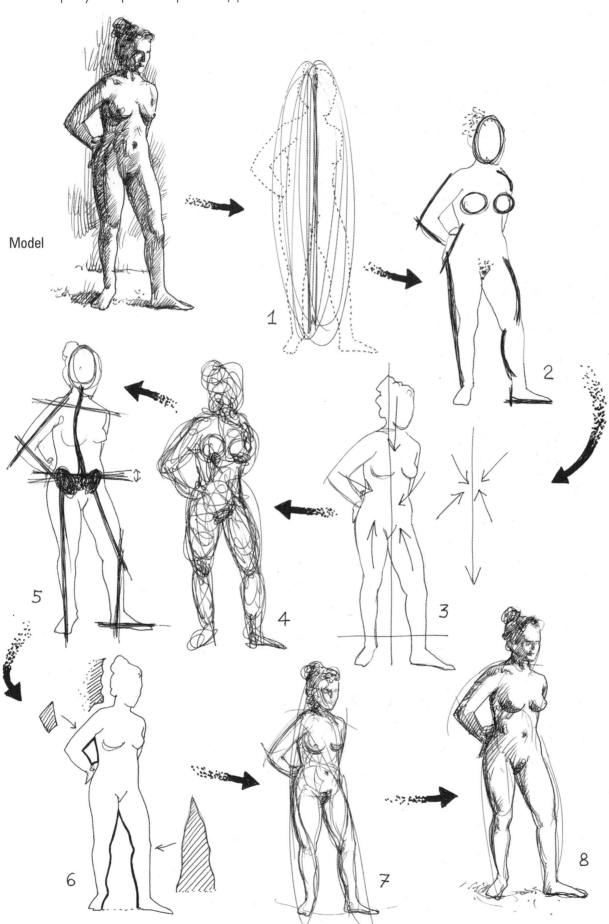

Model

1

2

3

4

5

6

7

8

PLATE 71 (OPPOSITE):
SOME FIGURE DRAWING METHODS AND STYLES

Featuring some of the many possible ways of drawing the human figure next to each other on the same page is useful in order to make brief comparisons and suggest ways of exploring various forms of expression, placing a taste for experimentation alongside a tenacious focus on detail.

1) Linear drawing – outlines only (see plate 55).
2) Drawing only the shadows (see plate 54).
3) Gesture drawing (see plates 57 and 58).
4) Drawing contrast and continuity lines, etc. (see plates 22).
5) Anatomical construction (skeleton, etc.).
6) Construction in geometric solids (see plates 3, 20 and 21).
7) Drawing lines and angles (see plate 48).
8) Considering the geometry of volumes and delineation of planes.
9) Assessing deviations and protrusions from vertical alignments (see plate 1).

Plate 71: Some Figure Drawing Methods and Styles

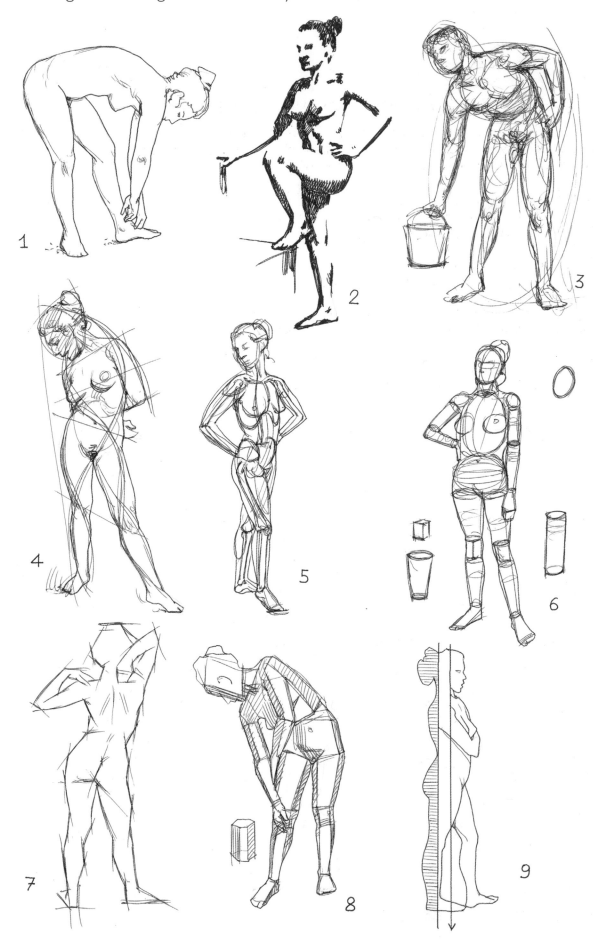

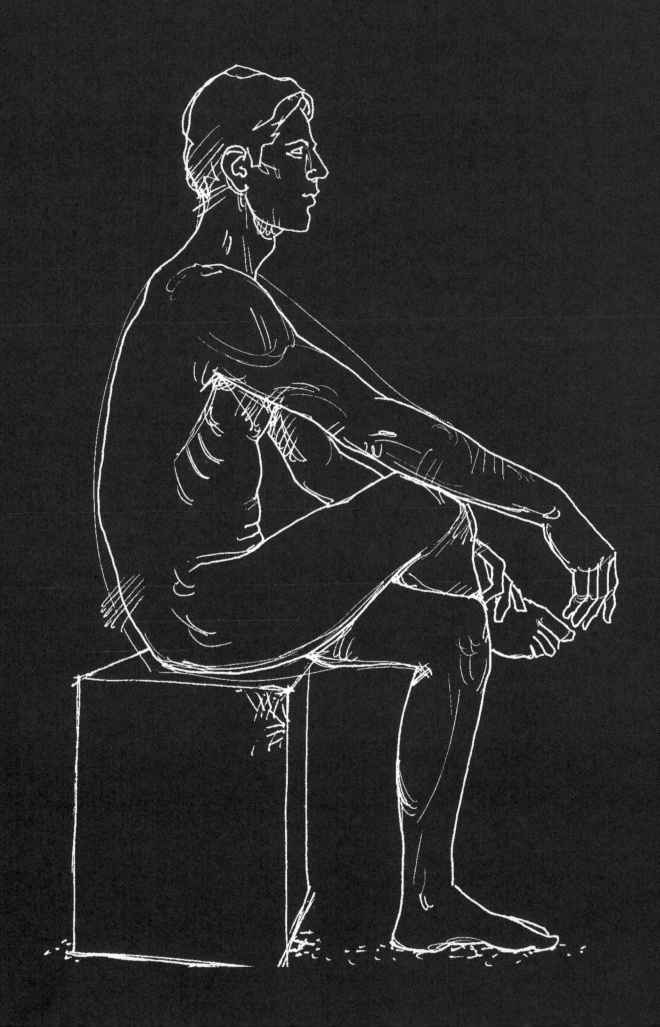

BIBLIOGRAPHY

Arnheim, Rudolf *Art and Visual Perception: a Psychology of the Creative Eye*, Regents of the University of California, Los Angeles, 1974 (1954). Ed. it. Feltrinelli, Milano, 1983.

Civardi, Giovanni *Studi di nudo*, Il Castello, Milano, 2000.

Dodson, Bert *Keys to Drawing*, North Light, Cincinnati, 1985. Ed. it. Newton Compton, Roma, 1991.

Edwards, Betty *Drawing on the Right Side of the Brain*, Houghton Mifflin Co., Los Angeles, 1979. Ed. it. Longanesi, Milano, 1984.

Fawcett, Robert *On the Art of Drawing*, Watson-Guptill Pub., New York, 1958.

Maffei, Lamberto and Fiorentini, Adriana *Arte e cervello*, Zanichelli, Bologna, 1995.

Massironi, Manfredo *Vedere con il disegno*, Muzzio e C. Ed., Padova, 1982.

Nicolaides, Kimon *The Natural Way to Draw*, Houghton Mifflin Co., Boston, 1969 (1941).

Prette, Maria Carla and De Giorgis, Alfonso *Capire l'arte e i suoi linguaggi*, Giunti, Firenze, 2000.

Toney, Anthony *Creative Painting and Drawing*, Dover, New York, 1966.

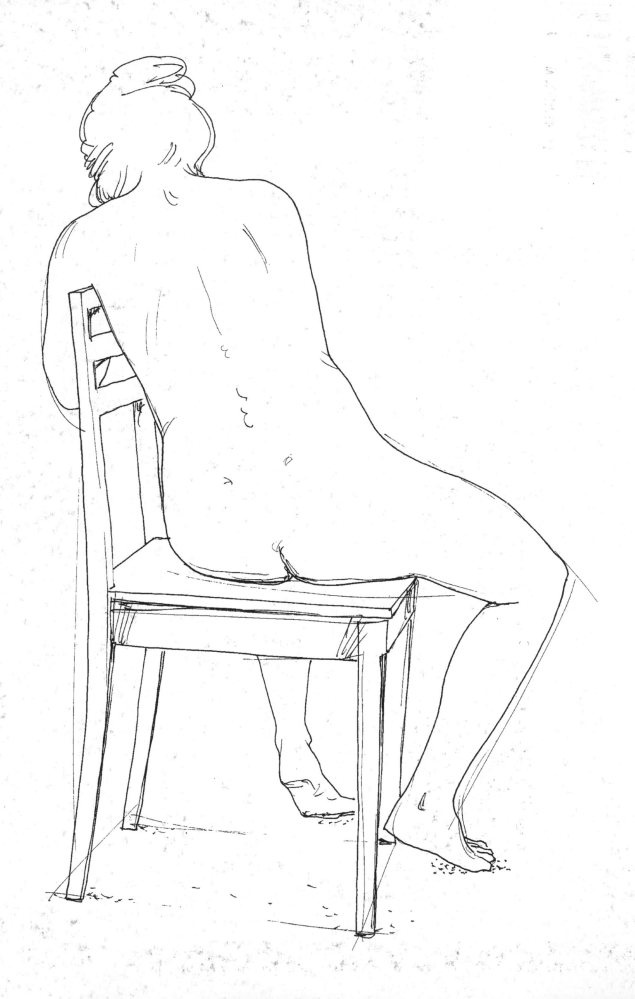